EX LIBRIS

RENAISSANCE ART
ART
A CRASH
COURSE

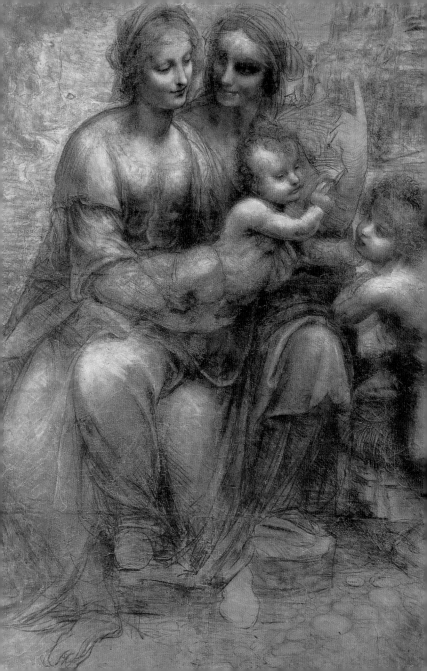

RENAISSANCE
ART
A CRASH
COURSE
DAVID BOYLE

PUBLICATIONS

New York

First published in the United States in 2001
by Watson-Guptill Publications, a division of BPI
Communications, Inc., 770 Broadway,
New York, NY 10003

www.watson-guptill.com

Library of Congress
Catalog Card Number: 00-110228

ISBN 0-8230-4523-4

This book was conceived, designed, and produced by
THE IVY PRESS LIMITED
The Old Candlemakers, West Street,
Lewes, East Sussex, BN7 2NZ, England

Art director: PETER BRIDGEWATER
Publisher: SOPHIE COLLINS
Editorial director: STEVE LUCK
Designer: JANE LANAWAY
Editor: GRAPVINE PUBLISHING SERVICES
DTP designer: CHRIS LANAWAY
Picture research: VANESSA FLETCHER
Illustrations: IVAN HISSEY

Printed and bound in China by
Hong Kong Graphic and Printing Ltd.

1 2 3 4 5 6 7 8 9 10/06 05 04 03 02 01 00 99 98

ACKNOWLEDGMENTS

*To Lucy Cutler,
with thanks*

Contents

Introduction 8

Angels on a Pinhead
The medieval world view 12

Urban Myths
The city states 14

Disappearing Points
Brunelleschi gets some perspective 32

The Doors
Ghiberti's single-minded career 34

The Furrowed Brow
Donatello's sculpture 36

Man and Superman
The cult of the individual 38

Time and Space
The age of measurement 40

The Benefits of Bad Government
The emergence of Siena 16

The Big Apple
The free city of Florence 18

Divine Comics
Dante, Boccaccio, and Petrarch 20

Pursed Lips
The arrival of Giotto 22

Clumsy Tom
Masaccio 42

Butt Naked
The rise of naturalism 44

Mystery and Mirrors
The Flemish revolution 46

Fancy Friars
Fra Angelico and Fra Filippo Lippi 48

Opening an Account
The arrival of the bankers 24

This Wallpaper is Killing Me
The development of frescos 26

Masters and Servants
The artists' workshops 28

The New Age
History and classicism 30

Men About Town
The new architects 50

Men Only
The Renaissance and sex 52

Lovely Linseed
The arrival of oils 54

Blue Skies
The love of landscapes 56

Filthy Rich
The Medicis 58

Getting Things in Proportion
Piero della Francesca 60

Marble Halls
The revival of Rome 62

Underneath the Arches
Bellini 64

Gentlemen of the Press
The rise of printing 66

Flower Power
Botticelli 68

Marble Bodies
The Lombardo family 70

Animal House
Bosch 72

Doges and Damp
The rise of Venice 74

Smoke and Smiles
The great Leonardo da Vinci 76

Simple Sounds
The rise of Renaissance music 78

Round and Round
Bramante 80

**The Magnificent Man
and his Flying Machines**
Leonardo's scientific genius 82

Divinely Terrible
Michelangelo 84

Over There
The discovery of America 86

Passion and Poison
The Borgias 88

Clowning Around
Renaissance theater 90

Funny Money
Pacioli and the new accountants 92

Scratching the Plate
Dürer 94

We Can Do It!
The High Renaissance 96

A Certain Smile
Mona Lisa 98

Drop Me a Line
Erasmus, More, and the humanists 100

The Charmer
Raphael 102

What Big Hands You Have!
Michelangelo's David 104

Priest in Armor
Pope Julius II 106

Gorgeous George
Giorgione 108

When Will You Make An End?
The Sistine Chapel ceiling 110

The Grand Tour
The Romanists 112

Philosophical Poses
The Vatican rooms 114

The Big Ego
Machiavelli 116

A Splash of Color
Titian 118

In Your Face
Holbein and the spread of portraiture 120

Here I Stand
Luther and the Reformation 122

Strange and Unusual
Mannerism 124

Scroll Over
Fontainebleau 126

Wobbly Lines
Mercator and maps 128

The World Upside-down
Tintoretto 130

In the Stars
Copernicus 132

Pillars and Posts
Palladio 134

Guru Status
Vasari and the invention of genius 136

The Renaissance Renaissance
How we've used the word since then 138

Glossary 140

Index 142

Picture credits 144

Introduction

Something peculiar happened in late medieval Italy, and historians and art critics have been arguing about it ever since. They don't agree when it started or when it finished. In fact, they don't agree why it happened at all. But one thing was certain: it fundamentally changed the way people felt about themselves and their place in the world for ever.

It was a time of radical artistic development, when painters and sculptors were discovering individualism, harmony, perspective, and realism in their portrayal of the human form—and rediscovering their enthusiasm for the old classical Greek and Roman worlds. But all around them, there were similar revolutions bursting forth as well—in science, numbers, trade, architecture, and astronomy. And, as if all that wasn't enough, others were busily launching the Reformation or discovering America.

Michelangelo's *David* is an enduring symbol of Renaissance ideals and values.

is devoted to an artist or group of artists, writers, scientists, or economists with something in common, and the story proceeds more or less chronologically. On each spread there are some regular features. It won't take you long to figure them out but check the boxes on pages 8-11 for more information.

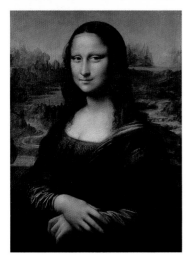

So how did Leonardo get her to smile like that?

For this reason, as much as any other, the Renaissance shouldn't just be for the art snobs. It was a crucial moment in the history of humankind, and we're still experiencing its effects. The images artists such as Michelangelo and Leonardo produced may have built the modern world— but as art they are still moving, exciting even, to look at.

TECHNO BOX
Insider knowledge about the new techniques, technical developments, instruments, and machinery that helped Renaissance artists to take giant leaps forward.

This Crash Course tries to be as chronological as possible, so that it becomes apparent how different areas of achievement in the Renaissance revolution fed off each other. It's also a good starting point for a tour of Italy, just as it offers us an interesting angle on the history of human ideas.

Timeline
More of a contextual chronology than a timeline, because artists and movements are constantly overlapping. A selected list of major events happening at the time each was popular, to illuminate the world they were working in.

The history books still argue about when the Renaissance began and ended, pushing the boundaries back and forward and making it look as if the

whole thing lasted for centuries. We have opted to start our story at that moment of stirring in the Italian soul that brought forth three magnificent writers of genius (Dante, Petrarch, and Boccaccio) who first sketched out a new way to think. And we mark the end with the era of slow disillusion and fear in the mid-16th century, when divisions between Protestant and Catholic seemed to tear the continent apart.

Further information about the ideas of the period. Don't be surprised if you find great artists and sculptors rubbing shoulders with accountants, mapmakers, bankers, and explorers. That's just the way the Renaissance was.

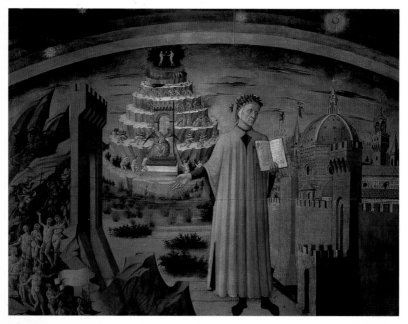

Dante with his *Divine Comedy*: was he responsible for the Renaissance?

We all need our "rebirths"—which is what the word "renaissance" means. Politicians, economists, scientists, and psychologists dream of it. The bookstores are full of instruction manuals about how we can achieve it ourselves. Historians hanker back to moments when,

Donatello's extraordinary and spiritual *Mary Magdalen* broke the mold of religious sculpture.

NAMES IN THE FRAME

Other artists working in the same styles or with similar subject matter. These are the figures in the background, but important nonetheless. Chances are that they were the friends and cheerleaders (or bitter rivals) of the greater artists.

for no single cause or obvious reason, there was a sudden gathering together, a whole new understanding and vision of what it might mean to be human. Of all those moments in history, the Renaissance was the very greatest.

DAVID BOYLE

1133 The first Bartholomew Fair is held in Smithfield, London; it will continue as an annual event for the next 700 years.

1167 England's first university is founded at Oxford.

1215 King John of England is forced to seal the Magna Carta, granting rights to his nobles.

1100~1416

Angels on a Pinhead
The medieval world view

If 21st-century Americans moan that their city centers look exactly the same from one side of the continent to the other, a millennium ago they would have had the same complaints about the art. Wander into any church or palace around 1300 and you would have found the same type of paintings—beautiful, awesome, but awfully alike.

Seen one painting, seen 'em all.

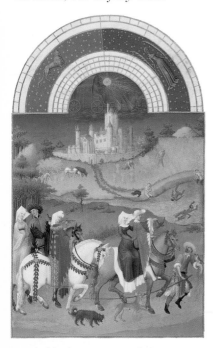

Medieval painting at its pinnacle: *Les Tres Riches Heures* (1416) was a beautiful book owned by the Duc de Berry.

The vast majority of art was religious. Even the everyday pictures depicting things such as the harvest were supposed to induce religious fervor and emotion. That was their purpose. Often the key religious figures in these pictures are made much bigger than those around them. It was a kind of theological perspective.

This was the period of the icon, with the figures often surrounded by gold. The pictures were there to facilitate prayer and to put across theological truths. They were not intended as a method of portraying things as they were scientifically or intellectually, nor as a new means of depicting human emotion. They did not attempt to confront any of the challenges that the great Renaissance artists would struggle with later.

A DIFFERENT WORLD

What was real to the medieval mind was the great hierarchy of heaven, stretching from God downward through the class system to the lowliest serfs and slaves.

1228 Francis of Assisi is canonized two years after his death.

1230 Crusaders bring leprosy back to Europe from the East.

1300 French professor Arnaldus de Villa Nova distills the first brandy at Montpelier medical school.

NAMES IN THE FRAME

The characteristics of the Gothic style that spread around Europe's burgeoning trade routes in the 1380s can be seen in the work of the Florentine artist **Gentile da Fabriano** *(c. 1370–1427). A good example is his* Adoration of the Magi *(1423), an altarpiece for the Sacristy of Santa Trinita, depicting the clergy dressed in the most sumptuous robes. Like many in this style, the frame has flowing golden arches and tracery—and is just as interesting as the picture itself.*

closest to the sources of Eastern spices and luxuries, and every trading city was expanding, spawning its own powerful patrons of the arts. In Italy these patrons were interested in commissioning what was a new Gothic style at the end of the 14th century— decorative and minutely detailed but often with very realistic settings. The stage was now set for the great revolution in art and culture known as the Renaissance.

Rebirth

The word "Renaissance" was first used in 1855 by the French historian Jules Michelet, meaning "the rebirth of the world and of man." "Rebirth" was a Renaissance idea in itself. According to Renaissance historians, they had just passed through the "Middle Ages," which was midway between classical civilization and what they saw as Renaissance enlightenment. The world lay at their feet.

Heaven was at the top and Earth at the bottom. Yes, medieval artists liked to portray awe and mystery, but they also liked to be organizers and codifiers: it was part of the medieval way to want to put everything in its proper place and quantify things—how many holy creatures existed in the air, how many archangels, how many demons. Hence the peculiar theological disputes about how many angels could exist on the head of a pin.

But the world was changing, and nowhere more so than in Italy, home of the bankers to the rest of the world. Italy lay

England's great contribution to medieval art: the Wilton Diptych (*c.* 1395), showing Richard II and Edward the Confessor.

1250 Cinnamon, cloves, cumin, ginger, and nutmeg brought back by Crusaders are now common in wealthy European houses but mostly used for medical purposes.

1261 Vikings on Iceland and Greenland accept Norwegian sovereignty.

1277 In Britain, scientist Roger Bacon dies of a cold following an experiment using snow to preserve a chicken.

1250~1400
Urban Myths
The city states

"The soaring mountains set against the fury of the barbarians"—that was how the poet Petrarch described the Alps. The people of Italy liked the Alps. They felt the mountain range gave them some claim to being a civilized race apart, constructing for themselves a wealthy and successful way of life, despite the political chaos (well, nothing's changed there), as various German emperors, popes, and French kings battled over control.

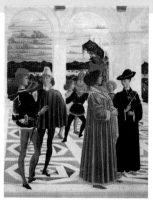

Urban living, Renaissance style: arches and painted floors. Perugino's *History of the Life of Saint Bernardino* (c. 1470).

As the light of the Renaissance began to glimmer on the horizon, cities such as Genoa, Milan, Venice, Pisa, Florence, and Siena were becoming immensely wealthy centers, increasingly fond of art—and competitive about it. The great rulers of these cities were all great patrons.

Since the 13th century, most Italian cities had introduced building controls and regulations to make the streets straight. The coming Renaissance would soon bring an interest in engineering, and a fascination for perspective and maps, which would help the Italian peoples make their cities beautiful places to live.

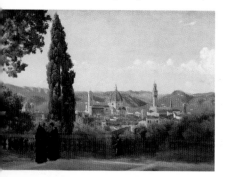

A 19th-century impression of Renaissance Florence by Jean-Baptiste-Camille Corot.

Papal removal

Compared to the splendors of Venice or Florence, Rome had lost the plot. It was dangerous, infested by mobs and extremely dirty. And in 1308, Pope Clement V took the decision to move out to Avignon—at that time part of territory ruled by Naples. (Of the previous two centuries, the popes had only spent around 80 years in the city anyway.) It was a brief period of 70 years when the Papacy could breathe a sigh of relief, reinvent itself a little, build lavish palaces, and live extremely well. But all the popes then elected were French, until Gregory XI took the risk of moving back to Rome in 1377.

1314 Mappa Mundi, a symbolic map of the world with Jerusalem at its center, is finalized.

1359 Welsh independence leader Owen Glendower mysteriously disappears.

1387 Chaucer's *The Canterbury Tales* is an immediate success and popularizes the literary use of English rather than French and Latin.

GROWTH OF A NEW CLASS

The relationships between the city states and all those interlocking trade and political links were so complex that it required a whole new class of people to watch over them. These were the first diplomats, who began making their appearance at this time, regularly writing long letters home. They were usually underpaid, but very pompous.

Italy has always managed to combine chaotic politics with successful trade, and in this respect, things in the Renaissance were little different. The great traders and bankers sent their wares across the known world with increasing sophistication, and mixed with aristocratic rulers and powerful churchmen. It was a new urban world, with a different class system from the servile countryside around it. There was a growing middle class, consisting of

NAMES IN THE FRAME

*The start of this period saw the Italian cities divided neatly into **Guelfs** and **Ghibellines**. During Holy Roman Emperor Frederick II's struggle with the Pope, Guelfs backed the Pope and Ghibellines (from the battle-cry "waiblingen") supported the Emperor. Naples was Guelf; Milan and Verona were Ghibelline. Florence was divided between the two factions, which eventually called themselves Blacks and Whites. What a complicated time to be a politician.*

lawyers, physicians, and teachers. But, as yet, artists did not figure: they were lower-class craftspeople and the object of snobbery. Then along came Giotto and put them on the first steps of the social escalator.

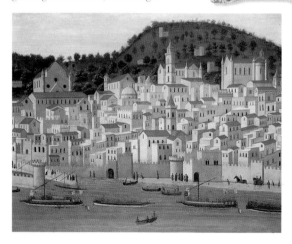

An unknown artist's view of the roofs and towers of Naples in the 14th century, when Neapolitans backed the Guelfs.

1264 Thomas Aquinas completes "Against the Errors of the Infidels," his treatise on reason and faith.

1265 Simon de Montfort summons representatives from the boroughs and shires in England to create the first English Parliament.

1300 Arabs invent the first guns.

1260~1430

The Benefits of Bad Government
The emergence of Siena

Lorenzetti's fresco on the *Effects of Good Government in the Country* (1338).

There's nothing like a good bit of stability to encourage local culture. In fact, when Ambrogio LORENZETTI (d. 1348) painted his enormous frescos on the walls of Siena's town hall, the Palazzo Publico, he chose to call them The Allegory of Good Government *and* The Effect of Good Government in the City and its Countryside *(1338). They consisted of a naturalistic picture of the road to Rome, with sweeping landscapes and a wealth of realistic detail. It was like nothing that had been painted before. But it was rather an unfortunate choice of title: within a decade, the city state of Siena descended into two centuries of the most appalling government. Unfortunately for Siena, Lorenzetti was right: without good government, the artistic revival slipped quietly away to Florence.*

In 1368 alone, Siena's constitution was changed four times in a desperate attempt to try to please all the different factions. Constant squabbles and wars, and several most inconvenient visits by mercenaries, undermined both the city and its population. In 1398, they handed it over, lock, stock, and barrel, to Milan to stop it falling into the hands of marauding neighbor Florence.

But Siena, with its spectacular cathedral façade and bell tower by *Giovanni PISANO* (d. 1314), was also one of the birthplaces of the Renaissance. And all because of the

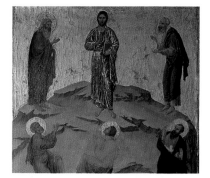

Duccio's *Transfiguration* (c. 1278): stark and spiritual compared to previous versions.

1392 The first playing cards are designed by French court painter Jacques Gringonneur.

1397 Kyoto's Golden Pavilion (Kinkaku) is completed at the Kitayama for the retired Ashikaga shogun Yoshimitsu.

1400 The Holy Roman Emperor Wenceslas of Bohemia is deposed for drunkenness and incompetence after 22 years on the throne.

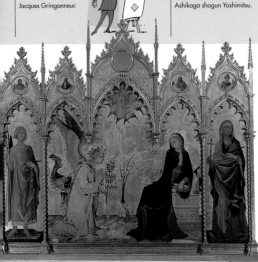

Mary shies away from Gabriel in *The Annunciation* in Siena Cathedral; by Simone Martini (1333) and now displayed in the Uffizi.

Courtly fashion

Martini took his experience to the Pope, in Avignon. His style, combined with the skills of the French manuscript artists, had become the height of fashion in courtly circles by the end of the century. With the arrival of the popes, Avignon was now the new spiritual center of Europe.

new style developed by the Sienese painter, *Duccio di Buoninsegna* (d. 1319), with its bold lines and color, and a suggestion of spirituality in the faces of the people he painted. His gigantic *Maesta* (1311) for the altar of Siena Cathedral had 50 separate panels. When it was carried in procession from his workshop, it astonished the crowds with its golden magnificence. Tragically, it was to be chopped into bits in 1771.

Duccio borrowed from the Byzantine tradition, and his influence led directly to the late Gothic style, which was distinctly Sienese, with its tall, elongated, graceful figures on golden backgrounds. These were the first shoots of the Renaissance, also emerging in the works of other Sienese painters such as Lorenzetti (active 1306–47), his brother *Pietro* (d. c. 1348) and *Simone Martini* (c. 1284–1344).

Martini was one of those responsible for *The Annunciation* (1333), an altarpiece for Siena Cathedral, with Mary shying away realistically from Gabriel, eschewing her traditionally rigid pose. Martini was a friend of the poet Petrarch and even painted a "portrait" of his great love Laura (*see page 20*)—one of the first recorded portraits to be executed and long since disappeared.

Realistic figures, the beginnings of expression in the faces, and landscape painting too. A century later it would all pop up again, except then it would be called Renaissance art.

TECHNO BOX

Simone Martini was the first artist to punch sophisticated motifs into the gold background of his paintings—as in Mary's halo in *The Annunciation*—and these would have shimmered mystically in the candlelight of the dark cathedral. The Sienese got so excited about punching patterns in gold leaf, that they started to export punching tools to Florence.

1296 Edward I takes the Stone of Destiny from Scone in Scotland to Westminster Abbey.

1341 Petrarch is crowned poet laureate in the Capitol at Rome.

1390 *The Forme of Cury*, the first English cookbook, is produced at the court of Richard II.

1296~1518

The Big Apple
The free city of Florence

If Dickens had decided to write his "best of times/worst of times" introduction about somewhere other than revolutionary Paris, 14th-century Florence would have been a likely candidate. It was a republican city state where only local merchants, bankers, and guild members could hold office and where even wool-workers got the vote; it had a brand-new cathedral and bridge, the Ponte Vecchio; and it could claim as its own Dante, Michelangelo, and great patrons of the arts such as the de' Medicis. It was also the scene of devastation brought by the Black Death in 1348, when half the city's 90,000 inhabitants died; and its political situation was so unstable that authority had to be given to distant princelings to fend off outside attacks.

> **TECHNO BOX**
> Brunelleschi invented a machine with pulleys to take building materials up to the top of the dome, and there were strict rules to stop people using it for rides. Florence wasn't that libertarian.

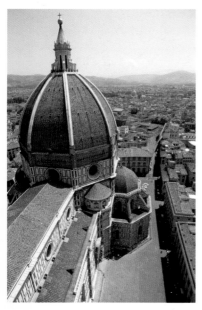

Brunelleschi's extraordinary dome (1420–36), which was constructed without scaffolding, was soon a famous symbol of the city of Florence.

I t was in fact this cacophony of competing tyrants and conspiracies that gave birth to Italian literature in the form of Dante (*see page 20*): he was born into a Guelf family, though it didn't stop them sending him into exile in 1301 for being on the wrong side of a squabble between Guelfs and Ghibellines. And now it was about to produce the sculptors Donatello (*see page 36*) and Ghiberti (*see page 34*), the painter Masaccio (*see page 42*), and the architect Brunelleschi (*see page 32*).

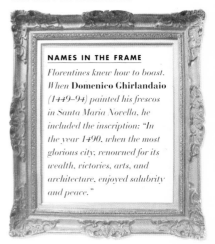

1403 The doge of Venice imposes the world's first quarantine as a precaution against the Black Death.

1429 The Battle of the Herrings ensues when Sir John Fastolf attempts to carry some fish to those under siege in Orléans.

1512 French king Louis XII imposes a tax on converted Jews from Portugal and the Spanish states.

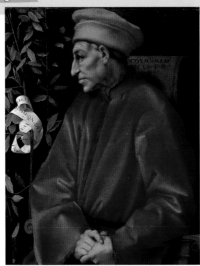

Pater patriae (c. 1518) by Jacopo Pontormo: Cosimo de' Medici may not have known about art, but he knew what he liked.

And if the center of Renaissance endeavor shifted later to Rome and then Venice, Florence carried on generating some of the great geniuses of the period until the whole movement finally petered out.

By the 15th century, Florence was the largest city in Europe. It was dominated by Brunelleschi's great cathedral dome, surmounted by the lantern designed by Michelozzo to let the light in. Florence was a place where people took enormous pride in their own liberty, ruled by a republican constitution and governed by the great merchants who made it rich, and were determined to make their city one of harmony and beauty. But it was the invitation to the great banker *Cosimo de' Medici* (1389–1464) to return from exile in 1434 that made all the difference.

Leader of the pack

Brunelleschi was the leader of the young artists who gave birth to the Renaissance in Florence. It is claimed the he was influenced by visits to Rome, when he measured the dimensions of the city's ancient ruins.

PATRONAGE AND GENIUS

His enormous political skill meant that neighboring rulers treated him as the de facto boss of Florence, and brought him the leisure time and wealth to launch a secondary career as patron of libraries, sculptors, and artists. Cosimo de' Medici became known as *"pater patriae"*—father of the country. After all, it was patronage as well as genius that drove the Renaissance.

NAMES IN THE FRAME

Florentines knew how to boast. **When Domenico Ghirlandaio** *(1449–94) painted his frescos in Santa Maria Novella, he included the inscription: "In the year 1490, when the most glorious city, renowned for its wealth, victories, arts, and architecture, enjoyed salubrity and peace."*

1303 Edward I's merchant's charter allows foreign merchants free entry and free departure from England with their goods.

1306 Robert Bruce becomes King Robert I of Scotland after murdering his old enemy John Comyne.

1313 German monk Berthold Schwarz invents the cannon.

1300~1375
Divine Comics
Dante, Boccaccio, and Petrarch

Dante had his Beatrice, Petrarch had his Laura, and Boccaccio had his Fiammetta. For some reason, the literary forefathers of the Renaissance all needed their romantic muses—in fact, Petrarch's encounter with love was so earth-shattering that we even know where and when he first set eyes upon her: April 6, 1327, in the church of St. Clare in Avignon.

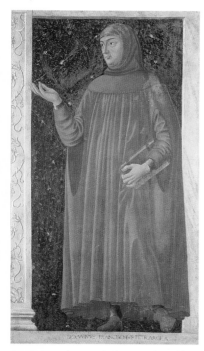

Portrait of Petrarch (c. 1450) by Andrea del Castagno in the Uffizi. In his favor it may be said that he was a great writer, but he wasn't a very good monk.

They had other things in common, too. They all made Florence their home, thoroughly admired each other—and they all had their shocking moments. For *Dante ALIGHIERI* (1265–1321), it was putting the Pope in hellfire in his *Divine Comedy* (1307–21); for *PETRARCH* (Francesco PETRARCA, 1304–74), it was fathering a child when he was supposedly celibate; and for *Giovanni BOCCACCIO* (1313–75), it was the shocking sexual exploits he described in his *Decameron* (1348–53), purportedly told by ten Florentine aristocrats in 1348. Together, they laid the foundations of a literary "humanism"—interested in individuals, and in rediscovering the same classical forms, subtlety, and imagination that were to underpin Renaissance arts.

In memory
Dante died in Ravenna, but the town steadfastly refused to hand over the poet's remains to his native city. Instead, a picture entitled *Dante Standing Before Florence*, with the poet wielding a copy of *The Divine Comedy*, was painted by Domenico di Michelino and placed in Florence Cathedral in 1465.

1362 William Langland's *Piers Plowman*, an allegory of a soul's journey to salvation, is completed.

1363 Kwanami Kiyotsugu, a famous writer/performer of Noh theater, has a son, Seami Motokiyu, who will be crucial in the development of monkey music.

1366 Toledo's El Transito Synagogue is completed by Meier Abdeli.

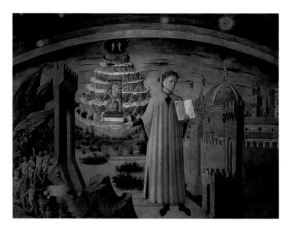

Domenico da Michelino's portrait of Dante (1465) lighting up Florence with his *Divine Comedy*, a description of Hell, Purgatory, and Paradise.

Renaissance writers looked back to Ovid, Horace, and Virgil to reinvent the old literary tradition. Not for nothing was Petrarch dubbed "the first modern man" and "the father of Italian humanism." And it was Petrarch who set the tone of the new age by dismissing the Middle Ages as "darkness." It was to be the battle-cry of the Renaissance ideologues, who followed not far behind him.

A WHOLE NEW LANGUAGE

There were differences, too. Dante shocked his contemporaries by writing in what they called the "vulgar tongue": a hundred years later they would refer to him as a "poet fit for cobblers" but in the present age he is seen as a pioneer of linguistic history. Petrarch was busily rediscovering his Latin forebears and inventing new rhyming schemes that would influence poets for centuries afterward. Boccaccio, on the other hand, wrote what was probably the first sustained prose in Italian, making an important contribution to the form of narrative fiction. He also devoted a quarter of a century to writing about his pal Dante, and it was Dante who hailed Giotto (*see page 22*), the founder of Renaissance painting, as the foremost among painters.

Just as the great Renaissance painters studied the works of classical sculptors to see how they achieved their effects, so

NAMES IN THE FRAME

Boccaccio felt rather ashamed of his Decameron *by the end of his life, but the book remained immensely influential across Europe. Its happy series of adulteries have been hailed since as a wonderful portrayal of humanity freed from the yoke of moral prohibition—athough the final story was about the incredibly chaste Griselda.*

1304 Moneylender Enrico Scrovegni commissions Giotto to create frescos for Padua's Arena Chapel, to atone for the sins of his father.

1310 Silk production increases in China as water power is used to unwind the cocoons.

1311 Notre Dame Cathedral at Rheims is completed after 99 years of construction.

1300~1337

Pursed Lips
The arrival of Giotto

There's an academic tussle about the frescos depicting the Life of St Francis in the Upper Church of San Francesco at Assisi. Italian academics tend to think they were by Giotto; others generally don't. But either way, they were among the first paintings to be produced in a whole new style, telling human stories in a quite unmedieval way —and as such they marked the dawning of the new age.

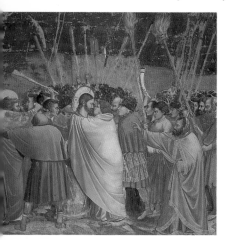

Giotto's *The Betrayal of Christ* (c. 1305) now at the Arena Chapel in Padua: his shallow backgrounds, figures gesturing like actors, emotive faces, and the use of shadow were all revolutionary.

But why do scholars argue so bitterly about it? Because *Giotto di BONDONE* (1266/7–1337) was almost a century before his time. His paintings were emotional, intense, and dramatically real— what critics call "naturalistic"—and they became an inspiration for the great standard bearers of the Renaissance such as Michelangelo and Raphael.

Giotto and friends used pictures to tell stories. Why? Well, partly it was because of their links with the new "mendicant"—or poor—monastic orders, such as the Franciscans, who needed preaching tools as they wandered around the new urban communities. But it was also an artistic challenge. Sacred moments were easy; so were emblematic poses, but stories—much tougher. Giotto showed how it could be done by depicting what people were thinking in their faces, or in how they used their hands. And if the people milling around in his pictures weren't exactly 3-D, they had depth, which added enormously to the sense of psychological excitement.

So there is a profusion of pursed lips in Giotto's frescos in the Arena Chapel in Padua (c. 1305), built for the rich merchant Enrico Scrovegni. Here is Judas kissing Christ in *The Betrayal of Christ*.

1315 The first public systematic dissection of a human body is supervised by Italian surgeon Mondino de Luzzi.

1334 The Mughal emperor Mohammed Tughlak greets Moorish traveller Ibn Batuta with lavish gifts in the hope that the Moor will help him conquer the world.

1337 English merchants are forced to contribute 20,000 sacks of wool to pay for the expenses of King Edward III.

Virginity

The classic virginal mother.

NAMES IN THE FRAME

It was the Florentine writers who recognized Giotto as a genius in his own lifetime. Boccaccio (see page 20) said he was the artist who brought art "back to light" after the darkness of the Middle Ages. Dante made sure he included a reference to Giotto in The Divine Comedy.

and Anna, the mother of the Virgin Mary, kissing her husband Joachim in *The Meeting at the Golden Gate*—encounters cut down to their bare essentials and portrayed as real human moments. And some of them also looking a little ill, thanks to Giotto's experimental green coloring.

The problem with Giotto is that nobody agrees quite what he painted. His Arena Chapel frescos—his masterpieces—are unsigned, and there is no documentary evidence that he actually painted them. The same goes for his frescos in the Bardi and Peruzzi chapels. His three signed altarpieces, on the other hand, just seem to be work done by his assistants.

Most of his contemporaries knew what he was, however: one of the first true artists who began the slow rise to echelons above the social level of craftsmen, and they adored him for it.

Why were so many contemporary paintings of the Virgin Mary? Thanks to the way the late Middle Ages were obsessed with romantic love and earthly beauty, Mary was emerging as an increasingly important religious figure—as the merciful, loving female aspect of what had been a pretty implacable male religion. That's why Renaissance artists were so fascinated by the Annunciation, or the image of Mary holding the body of Jesus in her arms—a dramatic human moment if ever there was one. And hence the dedication of the Arena Chapel to the Annunciation, and Giotto's portrayal of Mary's own immaculate conception. (According to the medieval theologians, if Jesus was born sinless, then Mary had to have been born sinless, too. Luckily, they didn't take the argument any further back than that.)

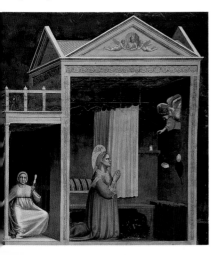

Annunciations were a habit in Mary's family: this is Giotto's version of her mother's (c. 1305).

1242 Gunpowder is introduced to Europe from the Far East.

1288 The first spectacles are invented to help short-sighted monks with their copying work.

1334 Poland's new king Casimir III encourages the immigration of Jews, who are needed as moneylenders and tax collectors, and grants them extensive privileges.

1229~1500

Opening an Account
The arrival of the bankers

Money men mingle in Florence: the Piazza del Mercato Vecchio; fresco by Giovanni Stradano (1555).

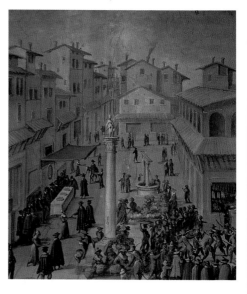

It's a strange thought that, at the beginning of this period, most people still used Roman numerals and handed over their basic arithmetic to someone else to do on an abacus. If you weren't initiated into the mysterious mathematical arts, that was that—you just wouldn't figure. The new Arabic numerals and the newly invented and mystical figure zero were even banned in Florence by a Church edict in 1229. They thought the new numbers spread the power of math dangerously down the social hierarchy—and zero seemed a satanic concept. It stood for nothing, after all. It seemed to deny the creation.

But a century on, the new numerals banished all that: calculations could be done by anybody—openly and on paper. You didn't have to rely on the peculiar rituals of the abacus: merchants could use the simple new numbers to make more ambitious and complex trading deals with Christian and infidel alike. It was a kind of liberation for them: zero rapidly became an underground symbol of resistance and free trade among the new generation— and history was on their side.

A messy business

It was only possible for merchants to work out whether they were making a sufficient profit by keeping detailed records. Hence the contemporary quote from a Florentine banker: "It befits a merchant always to have ink-stained hands."

1364 The first large-scale musical masterpiece, "Notre Dame Mass of Guillaume de Machaut," is performed at the coronation of Charles V of France in Rheims.

1397 The English parliament demands that Richard II submit a financial accounting and Richard has the parliamentary leader condemned for treason.

1475 The world's first coffee house, the Kiva Han, opens in Constantinople.

It was hard to work in business without using numerals, zeros, and negatives. Trade was a complicated business then, and the great Italian merchants knitted together fiendishly complex deals involving cloth and wool in various stages of production. They needed two ingredients for success. They needed the new numbers so they could keep books—the first double-entry bookkeeping was known as *alla veneziana* ("the Venetian way")—and they needed banks.

A LOAD OF BANKERS

Luckily, the great age of Italian banking, and especially Florentine banking, had just begun. The great banks of the early 14th century—Frescobaldi, Peruzzi, Acciaiuoli, and Bardi—were busy organizing loans and insurance, debt collecting, cashing bills of exchange, and exchanging currencies. They had branches all over Italy, as well as in London, Jerusalem, and Majorca. They had the wealth to patronize the new art, but unlike the nobility they also shared the more "democratic" attitudes of the new numerals.

Banking was a risky business. Bardi and Peruzzi

> **TECHNO BOX**
> The banks got round the Church's inconvenient ban on charging interest by pretending their loans were gifts, repaid with a little extra present in return. Merchant Francesco di Marco Datini took the spiritual precaution of starting each ledger with the words: "In the name of God and of profit."

went under in the 1340s after lending too much to Edward III of England for the start of the Hundred Years' War. By 1397, they had been replaced by the new Medici bank. But Italian banking supremacy didn't last long: by the end of the Renaissance the big banks were mainly Spanish or German.

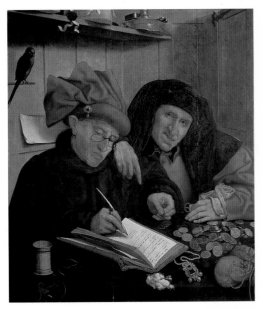

Jan Massys' *The Tax Collectors* (date unknown) makes his opinion of them pretty clear.

1306 A Londoner is tried and executed for burning coal in the city.

1312 Genoese mariners rediscover the Canary Islands; they had been known to the Romans, who called them the "Fortunate Isles," but subsequently forgotten.

1336 After seven years Andrea Pisano completes the decorated bronze doors for Florence's baptistery.

1305~1500

This Wallpaper is Killing Me
The development of frescos

The trouble with painting on walls and ceilings was that, after a while, even the greatest works of art tended to flake off and fall into the wine and food. This is not healthy, and it is not very encouraging for the artist either. At the beginning of the period most artists painted on wooden panels, but if you wanted a great, sweeping composition, you simply had to paint on the walls, and these pictures were known as frescos. Luckily, by the 14th century, artists had come up with a much more efficient method of wall painting, the "buon fresco."

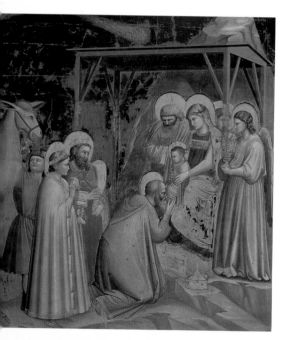

What most Renaissance artists did was to apply a rougher plaster (*intonaco*) to the wall, then either sketch the whole picture on to it, or stick a "cartoon" (sketch) on top, poke tiny holes in it, and blow charcoal dust through to mark the outline. Then they applied only enough fine plaster to stay wet for that day, painted into the wet plaster, and when it was dry, added a few other details. Exhausted artists had to paint fast to cover the new plaster before it dried.

Giotto's fresco *The Adoration of the Magi* (c. 1305) shows Halley's Comet swooping in the background.

c1348 Bubonic plague arrives in Europe from India or China; it will kill over a third of the population of Europe over the next five years.

1449 The first known patent is issued by Henry VI for the stained glass for Eton College.

1464 French king Louis XI founds the Poste Royale and pioneers a national postal service.

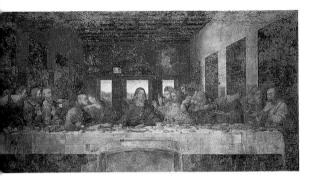

Melting wax

Things were in some ways easier for the sculptors, but still exhausting. Most bronze casting was done with "lost wax." You start by making a clay model, cover it with a thin layer of wax, then with plaster. When the plaster mold is heated, the wax melts and runs off. Fill the space left by the wax with melted bronze, and when it sets you've got a bronze statue.

THE MAIN INGREDIENTS

Giotto painted using the traditional medium of egg tempera (a mixture of eggs or glycerine solution and pigment in water), said to be the oldest type of painting in the world. The paint was applied to a surface of plaster of paris covered with linen, which was extremely absorbent, so the artist had to work very fast—an occupational hazard for painters in those days. There was no time for long, slow contemplation of their work in progress.

Leonardo's *Last Supper* (1495–97) flaking off the wall in Milan.

Nobody knows quite when anyone thought of painting in oils, but it wasn't until the time of Van Eyck (*see page 46*) that it became anything approaching commonplace—and we still have a good century to wait until then.

TECHNO BOX

Fresco secco (dry) had its problems, too. Leonardo da Vinci (see page 76) used it for the whole of his famous *Last Supper* (1495-97) on the wall of Santa Maria delle Grazie in Milan, and the painting has slowly disintegrated through the centuries. One of the reasons Leonardo's work has worn so badly is that he kept using experimental materials—we don't know exactly what. Why? Probably because he was a man almost incapable of finishing a painting, and he needed time to change his mind, paint out details, and have another go, which was almost impossible using *buon fresco*. *Fresco secco* doesn't last nearly as well as *buon fresco*, but even so it has survived better than many of Leonardo's efforts.

The impact of bronze: Verrocchio's *David* (*c.* 1472/76) with Goliath's head at his feet.

1314 Jacques de Molay, the grand master of the French Knights Templar, is seized by order of Philip IV, taken before the French Inquisition at Paris, charged with heresy, and burned at the stake.

1317 A fleet of Venetian great galleys makes the longest voyage undertaken by these trading vessels since ancient times, as a quarrel between Venice and France makes traveling overland difficult.

1350 The Middle English poem "Sir Gawayne and the Greene Knight" appears.

1310~1550
Masters and Servants
The artists' workshops

Artists at work in Florence.

The Renaissance wasn't one of those times when artists starved in garrets, although there were garrets and some of them did starve. In the 14th century, artists were much more like plumbers. You could call them out, along with other professionals, and they would come to your house and undertake anything from portraits to stage sets, book covers, or pictures on your furniture. But most of the time they spent their lives learning their craft in busy workshops, run by a master who got the commissions.

More like a cross between a courier and a decorator than an artist, a younger member of the profession would learn the way of art by preparing wooden panels for painting on, grinding out the colors, copying pictures, and generally making himself useful until he could get commissions in his own right.

Or he would be sent down to the apothecaries to buy the powdered pigments used to make paint. Apothecaries and painters, together with doctors and spice merchants, all belonged in the Guild of St. Luke in Florence. Saint Luke, among other things, was the patron saint of painters. When an artist was portrayed, it was usually as Saint Luke.

In fact, paints were so expensive that most painters waited until they had a firm commission before using them. In the early Renaissance, most contracts with artists specified the pigments they had to use along with their cost. But although the status of artists was rising after Giotto

Monks' colors
Expensive colors such as vermilion and ultramarine were usually supplied by monks—a relic of the days when most delicate painting and book illustration was done in monasteries.

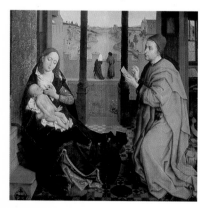

Weyden's *St. Luke Painting the Madonna* (c. 1435): St Luke, the patron saint of artists, was usually portrayed as one himself.

1362 English is adopted as the language of pleading and judgment in England's courts of law, but legal French continues to be used for documents.

1388 King Richard becomes the first royal to have his portrait painted from life and he gives the picture to Westminster Abbey.

1525 In Augsburg, Jakob Fugger II builds 106 dwellings for rental at low rates to the poor of the city, known as the Fuggerei.

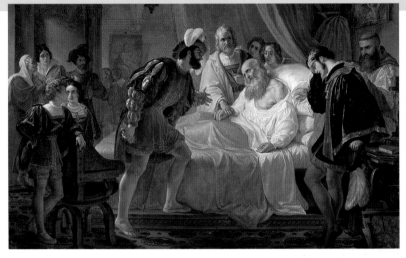

(*see page* 22), and there was competition for the services of the best of them, most of them were born of humble origin.

Michelangelo (*see page* 84) was an exception: his father was outraged by his decision to become an artist. Most of them were the sons of shopkeepers or traders, although by the time we get to the High Renaissance, the French king Francis I could cradle the dying Leonardo in his arms and Titian could boast about being bosom buddies with the emperor Charles V.

ALL THE RAGE

Even so, most patrons didn't want to tie up artists permanently or exclusively—none of them had enough altars, walls, or niches for that. But after Giotto, it became increasingly fashionable to own a piece of art. There were lucrative links, like the one between Pope Julius II and Michelangelo—

Cesare Mussini's *Dying Leonardo* (1828) shows the king of France at the artist's deathbed; it's unlikely but the story shows the upward mobility of artists at the time.

but that was pretty fraught and wasn't really exclusive. Increasingly, the most fashionable artists were able to dictate their terms. They were plumbers no longer.

TECHNO BOX

Look for the innovations of the mid-15th century. By the 1450s, canvas started to be used for paintings and theater scenery—rather than the customary wooden base, usually of white poplar. Most people believe canvas was invented by the Venetians, not just because of their knowledge of sails but also because the damp in Venice tended to destroy frescos and poplar wood wasn't very good for large wall paintings. And another great thing about canvas was that it could just be rolled up and moved.

By the 1470s, artists were starting to experiment with oil paints, copying the idea from Flanders. Mixing the pigments with linseed oil meant that the paint dried very slowly and they could build it up layer on layer.

c1348 Giovanni Boccaccio's bawdy *The Decameron* relates 100 stories told by nobles who have escaped the plague in Florence.

1360 In Britain, April 14, known as Black Monday, is reported to be "so full dark of mist and hail and so bitter cold that many men died on their horsebacks with the cold."

1409 Leipzig University has its beginnings in a college founded by émigrés from Prague.

1333~1505
The New Age
History and classicism

Donatello's classic *Gattamelata* (1445–53) in Padua's Piazza del Santo.

Big bronze
Check out Donatello's gigantic mounted statue of the mercenary Gattamelata (1445–53), deliberately modeled on the equally gigantic equestrian statue of the emperor Marcus Aurelius that still survives from ancient Rome.

History at school may have seemed sometimes like a long string of dates, but that was nothing compared to history medieval-style. Medieval history wasn't so much a good yarn, but more a lengthy catalogue of dates, weather reports, and miracles in which you could look things up. And the central role was usually played not by the powerful kings, princes, or popes, but by God. But Renaissance historians didn't really see things like that any more: they wanted interpretation, and they rejected the prevailing view of history as a branch of theology.

While medieval historians believed they were just clinging on by the skin of their teeth before the end of the world, their Renaissance counterparts had different ideas. They split history into three—the ancient classical times, the "Middle Ages," as they put it, and the wonderful, glorious age of rebirth that they happened to be living in then. Soon the

Calm, dignified and classical: Verrocchio's *Lady with the Beautiful Hands* (c. 1480).

new interpretation was set out in the *Twelve Books of Florentine Histories* (1420) by *Leonardo Bruni* (1370–1440), who was followed by a range of new historians such as Machiavelli (*see page 116*).

And along with the reappraisal of history went the rediscovery of the ancient world of Greek and Roman wisdom. Petrarch used to write letters addressed to Caesar, Livy, and Cicero and the other classical historians he admired; Italians were suddenly aware of their own heritage. There was

1424 German ecclesiastic Thomas à Kempis's *Imitation of Christ* will be the most widely read book in Europe, next to the Bible, for more than 100 years.

1457 Scotland's Parliament forbids "futeball and golfe" as their popularity threatens archery, which must be encouraged for reasons of national defense.

1475 England's Winchester Cathedral is completed after 425 years of construction.

Andrea del VERROCCHIO (1435–88)—before his fateful meeting with Leonardo da Vinci (*see page 76*)—rediscovering the artistic forms of ancient Rome. There was the artist *Andrea MANTEGNA* (1431–1506) digging up Roman ruins and recording the inscriptions on the stones. And there was Bruni, busily translating every bit of Plato and Aristotle that he could get hold of.

ROOTED IN THE PAST

History and the classics came together as they mourned the once-great city of Rome. "She who was once mistress of the world is now despoiled of her empire and her majesty," wrote the Florentine historian *Poggio BRACCIOLINI* (1380–1459), "her ruins alone showing forth her former dignity and greatness." They may have believed they were inaugurating a new age of civilization, but they weren't obsessed with being modern as we are these days. Their feet were firmly planted in the past.

NAMES IN THE FRAME

Bruni *burst upon the literary scene in 1401 with his panegyric about the city of Florence. But was his influential "humanism" really dragged from the classics, or was it just a reaction to the arbitrary despotism of Milan at the time? Either way, he was an important proponent of enlightened, humane political life—preferably republican. Although Bruni made some of the first translations of Plato, he didn't much like his authoritarian ideas.*

Caravaggio's view of the classical explosion (c. 1526) shows Renaissance archaeologists desecrating tombs.

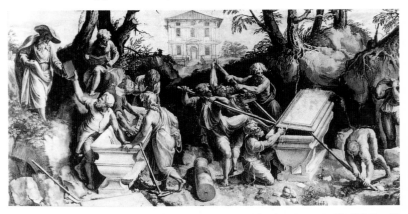

1377 The English parliament levies a 4-shilling poll tax that will lead to widespread rioting in 1381.

1380 French king Charles V dies at Vincennes after eating poisonous mushrooms.

1431 Joan of Arc is captured and sold by John of Luxembourg to pro-Duke of Burgundy allies for £80,000.

1377~1472

Disappearing Points
Brunelleschi gets some perspective

It all depends on your point of view.

Imagine the problem faced by the wife of the painter Paolo UCCELLO (1397–1475). When she complained that he stayed up all night working out the vanishing points for his perspectives, he would only shout back from downstairs: "Oh, what a lovely thing this perspective is!" The point wasn't just that the discovery of perspective was a revolutionary idea. It was also that when scenes disappeared into the distance to give the illusion of reality, they were—to Renaissance Man—endlessly beautiful.

The Florentine architect *Filippo BRUNELLESCHI* (1377–1446) first demonstrated the idea in paintings of the Florentine Baptistery and the Palazzo Vecchio, which have long since disappeared, although sketches and records still exist. It hit the Renaissance like a hammer on the head. His friends Masaccio (*see page 42*) and Donatello (*see page 36*) adopted the idea straight away.

Perspective into Practice

Although it was Brunelleschi who history credits with putting perspective into practice, his forerunners in the previous century had already been struck by the fact that black and white tiles seem to disappear into the distance. And it wasn't until Piero della Francesca (*see page 60*) that anyone grasped that the "disappearing point" depended on where your eye was. By then people like Leonardo da Vinci were looking for something better–a technique that would allow people to look at pictures from every angle and still get a sense of real life.

1451 The Ottoman sultan Murad II dies of apoplexy in Adrianopole after a 30-year reign.

1456 Sugar is brought to Bristol, England, from Madeira.

1472 The grand duke of Muscovy, Ivan III, brings in Italian architects to rebuild Moscow's grand ducal palace, the Kremlin.

with Uccello not far behind. But it was another architect, *Leon Battista ALBERTI* (1404–72), who wrote down the rules—using a grid through which you could see the world and transferring this to paper, and imagining parallel lines disappearing into the distance.

Artists showed off outrageously with their new technique, churning out complicated renditions of huntsmen disappearing into the distance—see, for

This 19th-century painting by Giuseppe Fattori shows Brunelleschi putting forward his plans for the apparently impossible dome he wanted to build in Florence; onlookers seem dubious.

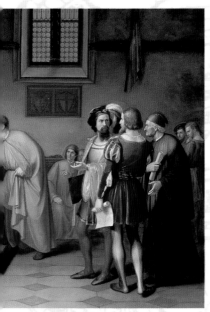

> ### NAMES IN THE FRAME
>
> *The more truth pictures convey, the more holy they are,* wrote the first Renaissance Man, Oxford scientist **Roger Bacon** *(c. 1214–94). A picture means that "the literal truth can be evident to the eye,"* he wrote, *"and as a consequence the spiritual truth also." He's the one who found errors in the Julian calendar and is credited with inventing gunpowder and magnifying glasses.*

example, Uccello's *The Hunt in the Forest* (1460s). Checkerboard floors started to proliferate; hardly a painting appeared without the obligatory columns getting smaller into the distance; and strange containers kept popping up for no obvious reason. But behind all the gimmicks, the real point of perspective was to control the way spectators looked at the painting.

Brunelleschi took up architecture after losing a competition to build the new Baptistery doors to Ghiberti (*see page 34*). His churches, like the Church of Santo Spirito (1436), use Roman-style Corinthian columns, curved Roman arches, and broader human spaces, which made a refreshing change from the cramped, dark medieval places they were used to.

1379 England's Winchester College is founded by William of Wykeham, and becomes a model for the nation's great public schools.

1380 The Apocalypse Tapestry, depicting scenes from the Bible, is completed in Paris after five years of work.

1382 John Wycliffe completes the first translation of the Bible into the English language.

1378~1455

The Doors
Ghiberti's single-minded career

Lorenzo GHIBERTI (1378–1455), the first great sculptor of the Renaissance, was nothing if not focused. He spent nearly his whole career creating two of three pairs of doors for the Baptistery in Florence. These beautiful, gigantic, gilded doors have inspired successive generations, but it cost him a good half century spent lavishing his work on one building. One might have to call him a little parochial— but then, this was Florence, and the whole world was looking to the city. So even doors were important.

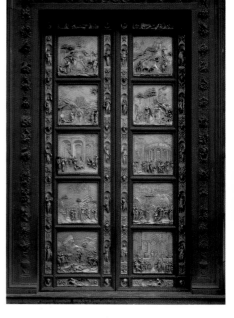

Ghiberti's bronze *Doors of Paradise* (1425–52), cleaned and gleaming, show New Testament scenes in high relief.

TECHNO BOX

This is how Ghiberti describes the new science of perspective in his final doors: "There were 10 scenes, each framed so that those which are nearest are seen to be larger than those farther off, just as happens in reality." Simple.

Up until 1401, Ghiberti was a goldsmith and painter. Then up cropped a competition to carve a bronze door for the Baptistery with Old Testament scenes. Ghiberti entered and won. Runner-up Brunelleschi gave up sculpture altogether in his disappointment and became an architect instead. Ghiberti was modest in victory: "By universal consent, and without a single exception the glory was conceded to me," he wrote in his autobiography—the first one ever written by an artist.

He rubbed it in by sticking at his doors for nearly 50 years, and setting up his own workshop to get the panels made.

1388 Venice signs a treaty with the Ottoman Turks in an effort to assure trading privileges in the eastern Mediterranean in the face of growing Turkish power.

1398 Merchant Richard Whittington is made lord mayor of London, having gained his wealth by importing silks, velvets, and other goods.

1452 Florence's Medici Palace is completed by architect Michelozzo di Bartolommeo for Cosimo de' Medici, whose family will retain the palazzo for 100 years.

CRITICAL JUDGEMENTS

Was he really a Renaissance Man? His autobiography made it very clear he wanted to be remembered as one, but later generations of critics are in two minds. Evidence against: a few too many Gothic arches in the pictures. Evidence for: his supporters cite the flowing Roman-style robes and perspective. The second set of doors include a panel called *The Story of Joseph*, which has a strange arched

Saving the doors

The doors were gilded beautifully, but by the 20th century they were so dirty you could hardly see them. Luckily they were among the few Italian works of art to be cleaned during World War II instead of being pummeled into dust. They went on to be damaged in the floods of 1966 and were finally removed out of harm's way to the Museum of the Opera del Duomo.

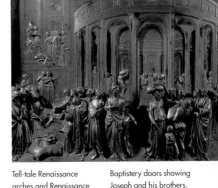

Tell-tale Renaissance arches and Renaissance perspective in a scene from a panel of Ghiberti's Baptistery doors showing Joseph and his brothers, every figure imbued with a personality of its own.

circular building in the foreground, using perspective in a whole new way. And there's Michelangelo's judgement on the second pair of doors, which he referred to as "the gates of paradise." Many of the next generation of Florentine artists trained in Ghiberti's workshop, picking up his ideas, including Donatello (*see page* 36), Masolino (*see page* 42), and Uccello (*see page* 32).

Where did he get the idea for doors like that? Not from artistic tradition, nor from his imagination, unfortunately for the critics. No, Ghiberti claimed he was inspired by a goldsmith he met in Cologne. To that extent, at least part of the inspiration for the Renaissance can be said to come from the intricate care and craftsmanship of the goldsmiths of northern Europe.

The Sacrifice of Isaac (1401): Brunelleschi's entry to the Doors competition came in second.

1393 A German price chart lists 1 pound of nutmeg as being worth seven fat oxen. In Europe, 1 pound of saffron is generally equal in value to a plowhorse, 1 pound of ginger will buy a sheep, and 2 pounds of mace will buy a cow.

1400 The Aztec Empire expands to cover most of Mexico.

c1411 Andrei Rublev's latest work *Trinity* confirms his reputation as the greatest Russian artist of his day.

1386~1466

The Furrowed Brow
Donatello's sculpture

Donatello's brilliant and languid version of David (c. 1433), at the Bargello, Florence.

It must have been a shock for the armchair art critics when it dawned on them that, in a few short decades, sculpture had gone from the stiff medieval madonnas in cathedrals to the pert, naked, pouting, erotic statue of David (c. 1433), wearing a hat and boots, in the courtyard of the new Medici palace (see page 50). It wasn't just that this statue was by the preeminent sculptor of the age, Donato di Niccolo di Betto Bardi—better known as DONATELLO (1386–1466)—it was also the first free-standing life-size Renaissance nude. What would they have made of it? The chances are that they simply wouldn't have understood it, and as his career unfolded, they understood it less and less.

Donatello was the son of a wool-comber from Florence, who at the age of 17 helped Ghiberti with his famous doors (*see page 34*). As a friend of Brunelleschi, he is supposed to have wandered around

Rome with him, looking at the intoxicating ruins. Not surprisingly, his work displayed both classicism and realism. Often frighteningly so. If you were used to statues

One of the more spiritual wooden sculptures: Donatello's *Magdalen* (1455).

The Miracles

Donatello's *Miracles of St. Anthony* (1443–53), for the high altar of the Basilica of St. Anthony in Padua (scene of six miracles during the previous 30 years), is a series of life-size bronze figures and massive reliefs, all under a canopy. It took him nearly ten years to complete—directly after which he was to fall out with his patrons and storm home to Tuscany. It has been reconstructed—in the wrong order—since the war.

1433 Timbuktu falls to the Berbers.

1440 Lorenzo Vale, who has made a scientific study of the Latin language, proves that the Donation of Constantine, used to justify the pope's authority over secular rulers of the time, is spurious.

1454 England's Henry VI recovers from a bout of insanity and dismisses the Duke of York as his protector.

of saints looking like rough-hewn lumps of stone, how would you have reacted to Donatello's *Magdalen* in the Florence Baptistery (1455), using extreme ugliness to demonstrate extreme holiness? The chances are you would have penned an outraged letter to the civic authorities.

A TRIUMVIRATE

Actually there are three Donatellos—or rather, three phases of his career. Donatello I shows the man himself still influenced by Gothic art, but employing increasingly realistic methods, as in his *St. George* (1417) for a niche in San Michele (one of his first furrowed brows and worried-looking features). Donatello II used the ancient sculptures as models, and teamed up with the architect Michelozzo (*see page 50*) to help him make bronze castings. The controversial *David* was the first statue to be cast completely in bronze since classical times.

Donatello rediscovers the classical style with his *St. George* (1417) complete with shield.

> ### NAMES IN THE FRAME
> *Donatello's immediate influence was most keenly felt by the sculptors of the next generation, such as* **Antonio Rossellino** *(1429–c. 1479),* **Desiderio da Settignano** *(1428/30–64), and* **Andrea del Verrocchio** *(1435-88). Rossellino and Desiderio reacted against all this macho heroism and concentrated on busts and reliefs of women and children. Since Verrocchio became Leonardo's first teacher, you can see the direct line of descent.*

Donatello III reacted against all that classical restraint and went for realism and action, full of romance and extremes of emotion—and stories too: Donatello has been described as the "Shakespeare" of sculpture. These statues influenced the new generation of portraits that were to follow shortly, which treated their subjects as individuals (*see page 38*).

There is another interpretation. That there's only one Donatello, working in stone, bronze, and wood, and in all three media pushing forward the boundaries of what's possible—even going so far as to use the ultra-modern technique of distorting bodies to make them look more lifelike.

1391 Seville has a pogrom in June that spreads throughout Andalusia as Spain seeks scapegoats for the Black Death.

1401 Inca terraces (*andanes*) turn steep slopes in the Andes into arable land, with soil carried up from the valleys below.

1411 A Celestine monastery is founded at Vichy by France's Charles VI.

1390~1520

Man and Superman
The cult of the individual

If the Renaissance could be summed up by one man, he would probably be looking at himself in the mirror and saying: "Hey, I never realized before what a cool guy I was!" Although art historians argue about when the discovery of the individual took place, there's no doubt that as the Middle Ages gave way to modern times, people were seeing themselves more as unique entities than they ever had before—and with dignity and pride. Gone was the crouched, hopeless medieval cringing before God. No longer do paintings depict people as merely symbolic manifestations of something else. They are there in their own right, with feelings and a point of view.

The art of frowning

Michelangelo's naked figures are straight out of classical art—with one difference. They look more worried.

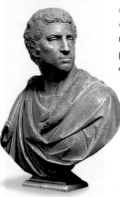

Michelangelo's *Brutus* (1538), with furrowed brow, as if he's just murdered Caesar.

With this new sense of identity and selfhood, it isn't such a surprise that the idea of portrait-painting began to emerge (*see page* 120), and we can still see these products of Renaissance enlightenment.

Michelangelo's *Slave* (1513–15), one of four designed for the tomb of Pope Julius.

looking at us, proud and sometimes a bit vulnerable, out of the canvas.

The new Renaissance educators stressed the development of the whole person—mind, body, and spirit. Historians were now studying the thoughts and actions of great men of the past, rather than just God's action on a hopeless, undifferentiated lump of mankind. Renaissance writer Giovanni Manzetti could write a treatise called *On the Dignity and Excellence of Man* (1452). It was an entirely new awareness.

1470 Thomas Malory completes his translation and retelling of *Le Morte d'Arthur*; whoever can pull the sword from the rock is the rightful king.

1510 *Everyman*, the English morality play based on the Dutch *Elckerlijk*, is performed for the first time.

1518 French silk merchant Jacques Le Saige, attending a ducal banquet in Venice, notes that "these seigneurs, when they want to eat, take the meat up with a silver fork."

INSPIRATION FROM THE PAST

Except that this isn't quite the whole story. In Italy, the new inspiration was coming not from the future, but mainly from the ancient past—the classical past of Greece and Rome (*see page* 30). Out went all those Gothic arches and in came naked statues of perfect human beings. It was a shocking shift to make for the medieval mind, which saw human bodies as part of our fallen natures, and only portrayed them as tormented souls in hell, or as Adam and Eve being thrown out of the Garden of Eden. The new generation saw things differently: out went crouched medieval corridors; in came Greek and Roman gods, mythology, and proud columns and buildings to suit the new dignity of mankind.

The remains of the Colosseum seen from Palatine Hill in Rome (1622) before it was recreated for the film *Gladiator* (2000).

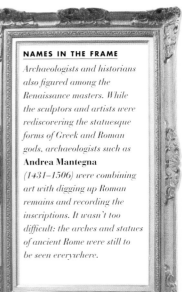

NAMES IN THE FRAME

Archaeologists and historians also figured among the Renaissance masters. While the sculptors and artists were rediscovering the statuesque forms of Greek and Roman gods, archaeologists such as **Andrea Mantegna** *(1431–1506) were combining art with digging up Roman remains and recording the inscriptions. It wasn't too difficult: the arches and statues of ancient Rome were still to be seen everywhere.*

1407 Chinese ships reach Ceylon.

1418 Rouen falls to Henry V of England after a two-month siege.

1429 The Order of the Golden Fleece is founded in Burgundy. It will become a Hapsburg order in 1477.

1390~1582

Time and Space
The age of measurement

The Renaissance pioneers belonged to the first generation to be brought up with the new phenomenon of public clocks in the town square, ringing out the hours. Not such a big change, you might think, but actually it was: previous medievalites experienced 12 hours of daylight and 12 of night—the hours would be longer or

A 13th-century timepiece in Salisbury Cathedral, the oldest known clock.

shorter according to the seasons. Clocks meant all the hours were exactly the same length, and their bells would ring them out, instructing people when to get up, stop work, or go to bed.

Measuring time wasn't the half of it. The Renaissance mind became obsessed with scientific measurement. Scholars at Merton College, Oxford, in the 14th century, preoccupied themselves with how humankind could measure not just size, taste, motion, heat, and color, but also abstract qualities such as virtue and grace. But then these were the days when even temperature had to be quantified without the use of a thermometer, which had yet to be invented.

Masaccio's *Trinity* (1426–27): get in close and you can see the perspective grid underneath.

They must have been exciting times for intellectuals, when the whole of quality—the arts and perception, and all that they implied— seemed to be collapsing neatly into science.

The great measurer of the age was the cardinal, mathematician, and calendar reformer *Nicholas* of *Cusa* (1401–64), who wrote a great treatise on weights and measures called *De staticis experimentis* (1450), and believed that measuring was a divine

1453 Greek scholars fleeing Constantinople are welcomed by Cosimo de' Medici to his palazzo at Florence.

1477 William Caxton, working in Belgium, produces the first book to be printed in English: *Deictes or Sayengis of the Philosphres.*

1509 The first watches are made in Nuremberg; they have hour hands but no minute hands.

calling: "Brutes cannot number, weigh, and measure," he wrote. Like a good Renaissance Man, he also discovered 12 forgotten comedies by the Roman playwright Plautus.

NAMES IN THE FRAME

The universe has no limits, wrote **Nicholas of Cusa**— *author of two of the earliest scale maps of Europe; it has no edge and no center. And just as he said so, the young Christopher Columbus was listening to stories of the Indies and the young John Cabot was dreaming of the fishing grounds off Newfoundland. The Renaissance world was about to lose its edges too.*

If clocks meant man could measure time, maps and grids meant he could measure space. And the grids appeared in the paintings, too. You can see the perspective grid still showing through underneath Masaccio's famous painting *The Trinity.* You could even see the grids appearing in the finished pictures, as checkerboard squares stretching away into the distance, each one carefully measured mathematically.

In fact, for the Renaissance, the whole universe was measured and gridded, stretching away into the distance.

In denial

Some dyed-in-the-wool conservatives insisted that people knew pretty well when it was day and night, and when the seasons changed, without the aid of the new counting devices. But anyone who thought that, said the forthright Lutheran Protestant reformer Philip Melanchthon *(see page 122)*, deserved to have someone "drop a turd" into his hat!

Uccello's grid: geometrical configurations underlie many of the figures in his paintings, such as in *The Wonder of the Desecrated Host* (1465).

1405 The Chinese emperor Yung Lo funds the Mongol eunuch Zheng He to set off on his first long sea voyage. He will open trade relations with countries as far afield as eastern Africa and Arabia.

1413 A group of butchers, led by skinner Simon Caboche, seize Paris and try to make the government more efficient but the Armagnacs soon regain control.

1415 Henry's archers plant pointed stakes in their midst at the Battle of Agincourt and the French cavalry is impaled or trapped in the mud wearing heavy armor.

1401~1428

Clumsy Tom
Masaccio

If you want to be remembered as a genius, there's nothing like dying young—and that's exactly what one of the key founders of Renaissance painting managed to do. Tommaso di Ser Giovanni di Mone—known as MASACCIO—died at the age of 27, even younger than Mozart. But he still managed to be one of the trio of pioneers, with Donatello (see page 36) and Brunelleschi (see page 32), who founded the Renaissance.

Techniques
Masaccio added a new trick to the perspective game, with its parallel lines and vanishing points (see page 32). In his fresco *The Tribute Money* (c. 1425), all the lines in the picture disappear into the spot occupied by Jesus' head, making it the focal point of the whole painting.

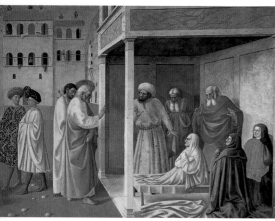

Masolino's *Raising of Tabitha* (1424–27), Brancacci Chapel, was partly worked out by Masaccio.

Masaccio looked slovenly and unkempt—the origin of his nickname "Clumsy Tom" —and his paintings look a little clumsy too. Great big lumpen figures with trademark rich folds of robes and fraught expressions, crowded into his paintings, with their heads ever so slightly too small for their bodies. And you won't see

What's more, his reputation is based on just three works, all done in the last four years of his life: the Pisa Polyptych, the frescos in the Brancacci Chapel in Santa Maria del Carmine in Florence, and the Trinity frescos in Sta Maria Novella (*see page 40*).

much of the detail so loved by the later Gothic stylists, either. It was as if he didn't have quite enough time.

Masaccio's poor partner, *MASOLINO di Panicale* (c. 1384–1447)—a graduate of Ghiberti's famous door factory—worked with him in the Brancacci Chapel, but did

1419 A Hussite crowd march on the new Town Hall in Prague and throw Catholic councillors out of the window into the square below.

1420 Jan van Eyck and his brother Hubert are among the first artists to use oil paint on wood to achieve rich colours.

1424 There are 122 volumes in Cambridge University library.

Masaccio's famous *Tribute Money* (above, c. 1425), in situ in Santa Maria del Carmine.

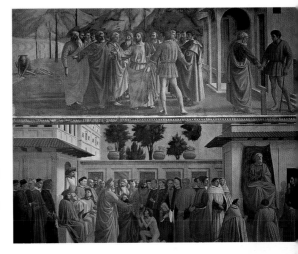

less well out of the deal as far as history is concerned. It was never absolutely clear which of them painted which frescos, so the best ones just got attributed to Masaccio. Masaccio was the master of light and shade: his work was shot with an exuberant thrill when it came to perspective, with lots of holes in the wall and distant views beyond. Sad, really: Masolino had a great deal to offer modern taste, with his sense of detail, but history went for Masaccio. Masaccio, who was a big friend of Donatello, had a whole new kind of perspective, and that was what was considered important.

What Masaccio also had, which no artist had managed since Giotto and his followers, who were all wiped out by the Black Death a generation later, was a sense of harmony. All the figures in the group have to be there—or so it's said: remove one, and the harmony of the painting falls apart. This sense of harmony would prove to be one of the most highly valued attributes in Renaissance painting.

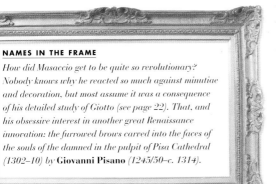

NAMES IN THE FRAME

How did Masaccio get to be quite so revolutionary? Nobody knows why he reacted so much against minutiae and decoration, but most assume it was a consequence of his detailed study of Giotto (see page 22). That, and his obsessive interest in another great Renaissance innovation: the furrowed brows carved into the faces of the souls of the damned in the pulpit of Pisa Cathedral (1302–10) by **Giovanni Pisano** *(1245/50–c. 1314).*

1405 Florence buys Pisa to gain direct access to the sea.

1411 A ban is pronounced on Prague's Jan Hus but he continues to preach in defense of the treatises written by John Wycliffe.

1423 Venice buys Thessalonica from Constantinople to keep the Ottoman Turks from taking the city.

1405~1487

Butt Naked

The rise of naturalism

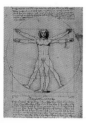

Leonardo's *Vitruvian Man*. (c. 1487)

The human body is a beautiful thing, said the pioneers of the Renaissance. What's more, it is the model for God's universe. You wouldn't have caught the medieval scholars thinking anything like that—for them, human bodies were shameful, smelly, and disgusting and the less that was seen of them the better. But in Leonardo's drawing, "Vitruvian Man" (c. 1487), you can see how a spread-eagled human body fits into a perfect circle, and with its arms stretched out, into a perfect square.

Real rooms

Tournai artist Robert Campin was the first to put holy people in real rooms. See, for example, his *Annunciation* (1425) which—apart from a whole new angular style of drapery—shows Mary with towels hung up on the wall, a couple of books open on the table, and what could almost be a shopping list. That's naturalism for you.

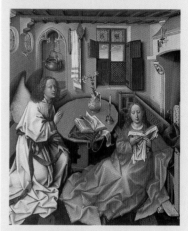

Flemish angular drapery in evidence in Robert Campin's *Annunciation* (1425).

"Everything that Nature produces is regulated by the law of harmony," wrote the Italian architect Leon Baptista Alberti (*see page 50*), "and her chief concern is that everything should be perfect. Without harmony this could hardly be achieved, for the critical sympathy of the parts would be lost."

And so it was that artists such as *Piero della FRANCESCA* (d. 1492) could use bizarre shapes from the classical geometry of the Greek mathematician Euclid to structure their paintings by using a kind of harmonic scale.

The implications of earthly existence being a potentially pleasant experience after all can be seen in all those perfect classical nudes churned out in Italy during this time, but something was also stirring in the Netherlands—and unexpectedly.

c1430 In Europe, complete suits of metal plate armor appear on the battlefields for the first time.

1445 Charles VII creates the first permanent French army; it consists of 20 companies of elite royal cavalry with 200 lances per company, and 6 men per lance.

1453 The White Sheep dynasty that will rule Persia until 1490 comes to power in the form of Uzun Hasan.

Because while the Parisian artists were painting for kings and princes, in the north of Europe they were tending to paint instead for the new wealthy bourgeois merchants. And out of the blue, to serve this new clientele, popped three of the greatest artists of the age—Jan van Eyck *(see page 46)*, Robert Campin, and Roger van der Weyden *(see page 47)*.

> **NAMES IN THE FRAME**
>
> *One of the peculiar habits of French artists at the time was to paint two of the Trinity—usually the Father and Son—as identically dressed young men with identical beards, more like a song and dance routine than an icon. See, for example,* Coronation of the Virgin *by* **Enguerrand Quarton** *(c. 1416–c. 1466), with the Holy Ghost portrayed as a dove between Father and Son. It makes for good balance as well as illustrating a theological point.*

THE SECRET OF LIGHT

Collectively these artists reproduced another aspect of nature, by painting precisely what they saw. Van Eyck used a revolutionary oil technique to create light, space, and texture, as in *The Arnolfini Marriage* (1434), which even has a mirror image in the tiny mirror painted at the end of the room *(see page 46)*. The use of intricate detail, borrowing from the tradition of Parisian miniaturists, was known as naturalism. Pictures of real things and real emotions: it was the northern contribution to the Renaissance.

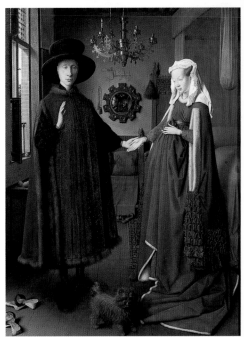

Van Eyck's revolutionary *Arnolfini Marriage* (1434) makes northern Europe come alive.

1410 A Latin translation of *Geography* by the 2nd-century astronomer-mathematician-geographer Ptolemy revives the theory that the world is round.

1421 Gypsies are noted arriving in Bruges for the first time.

1428 The bones of England's John Wyclif are disinterred 44 years after his death and burned by order of the Council of Constance.

1406~1464

Mystery and Mirrors
The Flemish revolution

Where did they all come from, these revolutionary artists of the Netherlands who appeared as if by magic at the start of the 15th century?

On reflection

Look out for the astonishing detail in the mirror in the back of the room in *The Arnolfini Marriage.* Who are those tiny figures reflected walking in the door? Are they supposed to be us? If so, it's not our reflection, but somebody else standing in our place. So where are we? You get to thinking these strange thoughts as you get more involved in the painting. And if that's all too disturbing, look at the tiny religious scenes around the mirror—each one recognizable and each one distorted by the convex glass on top.

There is no definite answer, but there is a clue, contained in the Latin inscription on the frame of the polyptych Adoration of the Lamb *(1432) in Ghent: "The painter Hubert van Eyck, than whom none was greater, began it; Jan, second in art, having completed it at the charge of Jodocus Vyd, invites you by this verse on the 6th May to contemplate what has been done."*

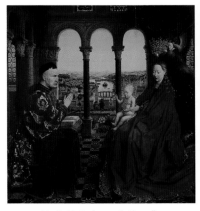

Van Eyck's *Madonna with Chancellor Rolin* (c. 1435) has a detailed view out of the window behind them.

The line that first reveals the existence of Jan van Eyck has fascinated art historians ever since. There is very little evidence for the existence of Hubert, but we know that Jan was working as court painter for Philip the Good, Duke of Burgundy, through the 1420s. And, although

TECHNO BOX

A small hint: how can you tell it's a Flemish painting you're looking at? Look at the folds of their robes. The Italians tended to have them hanging down carefully like curtains. The Flemish painters preferred them in strange angular bunches, as if someone has screwed them up—see, for example, the *Virgin and Child in an Interior*, possibly by Daret (c. 1435). The same pattern was also spreading down to Italy and north to England, where you can see it in the wall paintings in the chapel in Eton College (1480).

these artists didn't actually invent oil painting, as some have claimed, they used it as nobody ever had before. Just look at the detail of the stupendous view in

1446 Ireland's Blarney Castle is completed by Cormac Laidhiv McCarthy, Lord of Muskerry.

1448 Vlad, prince of Wallachia, escapes his Ottoman captors and assumes the throne of his father. The Dracula legends will be based on him.

1454 Burgundy's Philippe le Bon takes the "vow of the pheasant," swearing to fight the Ottoman Turks.

Madonna with Chancellor Rolin (c. 1435) and the fascinatingly detailed mirror in *The Arnolfini Marriage* (1434).

White faces and bizarre animal heads feature in Hugo van der Goes' *Portinari Altarpiece* (c. 1475).

It is for unflinching realistic detail that Van Eyck is remembered most of all, while his Flemish colleagues are held in high regard for their emotional realism. But it's still all rather mysterious.

The whole tradition probably began with *Robert CAMPIN* (1378/9–1444), working in Tournai from 1406. Few of his pictures have survived. He could have been the artist known as the Master of Flemalle —but nobody knows. He probably had two pupils who went on to great things in Renaissance art: *Jacques DARAT* (d. after 1468) and *Roger van der WEYDEN* (1399/1400–1464), who displayed in his art a sensitive, emotional sense

NAMES IN THE FRAME

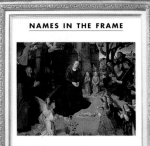

Don't forget another mysterious Flemish figure: **Hugo van der Goes** *(d. 1482). He was the Van Gogh of his generation, in that he became a monk and went crazy during a visit to Cologne, dying shortly afterwards.*

of holiness. Take a look at Weyden's masterpiece *Deposition* (c. 1435)— there's nothing dispassionate about that. Yet emotional Roger and dispassionate Jan shared center stage in northern Europe through the middle of the century.

Weyden's *Deposition* (c. 1435), in the Prado, Madrid: rich color and fluid lines help to evoke emotion.

1420 Sugarcane from Sicily is planted in the Madeira Islands.

1422 Lisbon becomes Portugal's seat of government.

1440 Eton College public school is founded in Britain by King Henry VI.

1420~1469

Fancy Friars
Fra Angelico and Fra Filippo Lippi

For all their talk of "humanism" and their excitement about rediscovering classical gods, the Renaissance artists still turned to religious subjects. Religion still played a central role in society, so perhaps it shouldn't be surprising that some of these artists were actually monks.

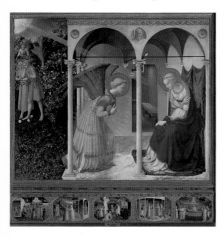

Sunlight direct from God: Fra Angelico's *Annunciation* (1436), was commissioned by Cosimo de' Medici.

Fra *Angelico* (*c.* 1400–55) and *Fra Filippo Lippi* (*c.*1406–69) had both taken the usual holy vows, both came from Tuscany, and both combined some of Masaccio's 3-D figures and the new perspective cult with some of the old-fashioned bright colors of Gothic art. But that's where the similarities between them end. Where Fra Angelico's paintings such as *The Annunciation* (1436) are serious, calm, spiritual works, Lippi's paintings are human, sweet, and joyful. If you want a picture depicting the love of life, then take a look at his *Madonna and Child* (*c.*1455),

with its angel grinning at us out of the canvas.

Not surprisingly, this difference was reflected in their lives. Angelico was a pious Dominican friar, later prior of the convent in Fiesole. Lippi was a Carmelite monk who had an affair with a nun, Lucrezia Buti, in his fifties, and eloped with her in 1456. They had two children, one of whom was the artist Filippino Lippi (*see page 68*). Luckily for

Birth dates

Most histories used to give the year 1387 as Fra Angelico's birth, but that left them with a problem. How come he didn't seem to take up painting until 1428? It doesn't matter how many illuminated religious books he managed to get through before then—it still seems a bit strange that one of the foremost Renaissance artists should emerge suddenly, and without training, in his late middle age. Scholars now agree on the whole that he was actually born around 1400, which means Pope Eugenius IV's favorite artist began his career at the relatively advanced age of 28.

1456 "Le Petit Testament" by French poet François Villon is published in 40 verses.

1459 The realm of an African king named Prester John appears on a map drawn by the Venetian monk Fra Mauro.

1462 Vlad the Impaler slaughters 20,000 Turks along the Danube, before he is deposed and replaced by his pro-Turkish brother.

Lippi, he was friendly enough with the Medicis to wangle a special dispensation to marry, and to escape from his own fraud trial in 1450.

But then Angelico's frescos, like those in the monks' cells of the convent of San Marco in Florence (1436), were often intended as aids to prayer and meditation, or as shining and colorful paintings decorated with cherubs—see *The Deposition* (c. 1440–5). He liked odd clothes, flowing robes, and flowers and his figures were more like those in the old medieval Gothic style.

NAMES IN THE FRAME

Contemporary with the monks were two short-lived but mysterious and influential figures. **Andrea del Castagno** *(c. 1421–57) translated Donatello's sculptural style (see page 36) into painting. It was said later that he murdered his great contemporary* **Domenico Veneziano** *(d. 1461)—but since he died first, this seems rather unlikely. Domenico may even have painted the bottom half of Angelico's Coronation of the Virgin (c. 1480).*

FLOWERS AND VIRGINS

Lippi painted flowers and shooting spirits into the room, too. Both share Masaccio's penchant for bulky people standing around looking at each other. But then Lippi had tradition on his side. He was probably Masaccio's only pupil, and he became the teacher of Botticelli. His facially beautiful Virgins, angels, and Christ children (see his *Pitti Tondo*) set the pattern for the next two generations; all of them are very friendly types.

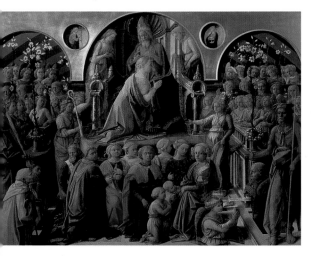

Uncharacteristically miserable-looking faces in Lippi's *Coronation of the Virgin* (c. 1480).

1420 Florence fails in an attempt to put a 20 percent ceiling on interest rates charged by Florentine bankers.

1422 England's Henry V dies of dysentery at Vincennes, protesting that he wants to live so that he may rebuild the walls of Jerusalem.

1430 French poet Christine de Pisan dies; some consider her a very early feminist.

1420~1472
Men About Town
The new architects

Alberti, as seen 400 years later in a monument by Lorenzo Bartolini.

What was it about Renaissance people that caused them to evolve the concept of Renaissance Man? It wasn't just that they were brilliantly creative, often in a whole range of fields. It was also that they saw themselves as part of a whole new way of thinking. Sometimes they believed they were quite alone thinking these great revolutionary artistic thoughts, surrounded by the horrible machinations of the power-hungry and the gloom of the late Middle Ages. It was a lonely business, being Renaissance Man.

Take the architect *Leon Battista Alberti* (1404–72), the illegitimate son of an exiled Florence family. What was he? A scholar, scientist, mathematician, cryptographer, and pioneer of artistic theory—and still he had time to reshape Italian buildings. Not only that, he could jump

A façade in Padua designed by Alberti but built (1472–80) after his death.

TECHNO BOX

Both Michelozzo and Alberti built great town houses—known as palaces—in Florence. Both architects opted for three tiers and classical, rounded arched windows. They both used patterns of flat bricks, and both had projecting roof cornices on the top like hats. But while Michelozzo's Palazzo Medici-Riccardi was copied by everybody, nobody tried to copy Alberti's Palazzo Rucellai (c. 1436). To people like you and me, they look pretty alike, although Alberti's looks just a little bit too careful. The Rucellai was, in fact, based loosely on the ancient Roman Colosseum. Both Rucellai and Riccardi were copied outrageously in the 20th century for the design of the Federal Reserve of New York, the setting for the Bruce Willis film *Die Hard with a Vengence.*

with both feet together over the head of a man standing in front of him. It wasn't until he was traveling in service to Pope Eugenius IV to Florence that he realized, as he put it, that the arts could be revived.

1438 The Inca dynasty that will rule Peru and much of the Andes until 1553 is founded by Pachacutec.

1438 Eric VII, King of Denmark, Norway, and Sweden since 1412, flees peasant rebellions, takes refuge on the Swedish island of Gotland, and turns pirate, preying on Baltic shipping.

1449 In China, building work begins on the Great Wall which will give it its present-day appearance. The original dates from the 3rd century B.C.

MUSIC AND BUILDINGS

Architecture is beautiful because it is harmonious, Alberti said, writing the very first treatise on perspective. It has to have fixed numerical proportions, derived from the intervals between notes in music. The result was some of those strange arched porches you see in the background to so many Renaissance pictures—like his façade of St. Andrea in Mantua (*c.* 1470).

NAMES IN THE FRAME

The year Michelozzo got down to building the Medici Palace, his successor, Donato Bramante (see page 80)—the great architect of the High Renaissance—was born near Urbino. He was just in time to be on hand for Pope Julius II's massive reshaping of Rome at the end of the century.

New York's Federal Reserve, built in 1924 by architects York and Sawyer, was modeled on the Renaissance palaces of Florence.

He and his great contemporary *MICHELOZZO di Bartolommeo* (1396–1472) both took their lead from Brunelleschi, learning as much as they could from classical antiquity. But whereas Brunelleschi wanted light and simplicity in his churches, Alberti wanted awe-inspiring gloom. When it came to town houses, Michelozzo's were immensely popular, while Alberti's were just too revolutionary.

So it was Michelozzo who progressed from helping Ghiberti with his blessed doors to win the support of the Medicis. And it was Michelozzo who teamed up with Donatello to build some of the great tombs of Florence and Naples, and who built the Medici Palace in Florence (1444*f*) – dubbed by contemporaries as "comparable to the works of the Roman emperors." It was just the praise they wanted.

1422 News leaks of the secret marriage of dowager Queen Catherine de Valois (widow of Henry V) to obscure Welsh squire Owain Twdwr.

1428 The University of Florence begins to teach Greek and Latin literature with special emphasis on history and its bearing on human behavior and moral values.

1441 African slaves are sold in the markets of Lisbon, beginning a trade that will see more than 20 million Africans transported to Europe and the New World in the next 460 years.

1415~1600

Men Only

The Renaissance and sex

If you were to point out that Michelangelo and friends were much better at the male form than the female, sadly you would not be making an earth-shatteringly original observation. There were, of course, busloads of madonnas out there—but they tended to be fully clothed. There was something about the male physique that fascinated the men of the Renaissance. Their blatant interest caused raised eyebrows in the generations that followed; and it wasn't long before another artist was commissioned to paint demure robes over some of Michelangelo's more obvious private features.

David Apollo (1530): Michelangelo knew his way around men's bodies.

The revolutionary monk Savonarola preached fiery sermons of purity, as shown in Gemalde's *Savonarola Preaching in Florence* (1850s).

Was homosexuality particularly rife in Renaissance Italy? It's hard to tell, but they certainly thought so at the time. The local authorities were obsessed with it and were endlessly passing laws setting out horrific new punishments—including burning—to anyone caught at it. Florence passed statutes against "sodomy" in 1415, 1418, 1432, 1494, and 1542. And the rise of the monk-revolutionary and moral reformer *Girolamo SAVONAROLA* (1452–98) increased the moral panic. Even Leonardo da Vinci faced a dangerous accusation of sodomy in 1476 (he was acquitted).

1532 In *The Prince*, Machiavelli says "Men sooner forget the death of their father than the loss of their possessions."

1542 Spanish conquistador Gonzalo Pizarro returns to the mouth of the Amazon after an eight-month journey in which he has reached the river's headwaters and been attacked by Indian women.

c1576 The first English playhouse, the Theatre, is built by James Burbage in London.

Actually, we don't really have any more detailed knowledge of Renaissance attitudes to homosexuality, although it was clearly a trendy part of rediscovering ancient Greece, where people had a penchant for such things. And, in fact, hardly anyone was ever prosecuted.

Where were all the Renaissance women? The truth is that they had hardly any opportunities to participate in what was going on around them. Very few were educated, and if they failed to marry, they were left the choice of becoming either a servant or a nun. About 12 percent of Florence's women chose the latter option—although Michelangelo's friend *Vittoria Colonna* (1490–1547) was a successful poet and powerful religious force. There was an outpouring of treatises arguing that women were equal to men —but all of them were written by men.

Prostitution was increasing, especially in Venice and Rome, and Florence had special civic brothels that provided about one prostitute for every 300 members of the adult population. With old age loomed the prospect of begging, being institutionalized in a special workhouse for the repentant, or—after the arrival of syphilis in the 15th century—an even more dangerous prospect.

Nun's the word

It was extremely hard for women to establish themselves as artists because they were not allowed to be workshop apprentices. Only nuns managed to learn the skill, notably Abbess Plautilla Nelli, who painted a major fresco of the Last Supper in Santa Maria Novella in Florence, and Orsola Maddelena Caccia who organized a painting studio in her convent.

Leonardo's nude studies (c. 1506–7) have been open to misinterpretation.

NAMES IN THE FRAME

It was the age of the great poet-courtesans, and among them, two are particularly noteworthy: **Tullia D'Aragona** *(c. 1508–58), one of the best known high-class prostitutes of the age, published her own books of poems, while the Venetian courtesan* **Veronica Franco** *(1546–91), who chose her mother's profession because she liked it (or so it was said), gave it all up to found a special home for retired prostitutes.*

1421 The North Sea engulfs more than 70 Dutch villages and more than 100,000 people die as the shallow Zuider Zee floods over thousands of square kilometres.

1429 The Grocers' Company is formed in London to succeed the Spicers' Guild of 1180.

1433 Chinese explorer Zheng He returns from an expedition bringing tributes to the Ming emperor, including giraffes and zebras.

1420~1600

Lovely Linseed
The arrival of oils

The exotic new spices and pigments may have poured in through Venice—ultramarine for blue, orpiment for yellow—but for once it wasn't the Italians setting the pace about how they were used. No, it was up in the cold north, in the Netherlands, where painters hit on the idea of mixing the pigments with oil instead of water.

TECHNO BOX

The names of the pigments reflect an age influenced by exotic imports from strange eastern lands. Artists tended to use ultramarine for their blue paints, made from ground up lapis lazuli which only came from Afghanistan ("ultramarine" means "from across the seas"). If you couldn't afford it—and ultramarine cost more than gold leaf—you would fall back on cobalt for blue. That's why the Madonna is depicted dressed in blue: she gets the most expensive paint.

D id Van Eyck invent the idea of mixing colors with linseed oil? Probably not, but he certainly showed what could be done with it. The great thing about it was that, unlike frescos, oil paintings dried slowly. You could correct mistakes and build up a picture, layer on layer, with increasing levels of detail—and Van Eyck could really do detail. He was also a dab hand at shading, which was always

Van Eyck's *Man in a Red Turban* (1433), probably a self-portrait, has a confident inscription: *"Als ich kan,"* meaning "As only I can."

difficult when working within the time constrictions imposed by fresco-painting and using opaque egg tempera paints.

Here's the recipe. First find a slightly absorbent surface, perhaps canvas (although actually canvas didn't reach the northern artists until the 17th century). Next mix the pigment with just enough oil—either linseed, poppy, or walnut—to make it sufficiently sticky to put on the end of a brush. Then either stick it straight on, or paint the color on top of a monochrome

1472 The world's first printed music appears in Bologna.

1510 Sunflowers from the Americas are introduced to Europe by the Spanish.

1592 Robert Greene's book *A Groatsworth of Wit Bought with a Million of Repentance* is published.

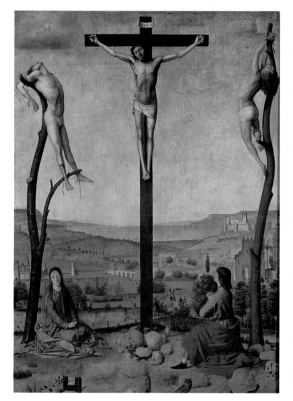

Antonello da Messina's *Crucifixion* (1460s) displays Flemish techniques and mastery of detail.

state stipend, finishing off his San Cassiano Altarpiece (1475–6), with its detail, perspective, and bright colors, and exerting his influence on Bellini's portrait-painting (*see page* 64).

Soon Leonardo would be creating his famous "smoky" effects (*see page* 76), and the old, clear lines would give way to shadow and mystery. Although the outlines are distinct enough in his rough cartoons, when it came to the few paintings he actually finished, they all but disappeared in the atmospheric color. No more the sharply drawn lines of Botticelli or Giotto. It seemed the future lay with oil and "smoke."

lower surface which can then shine through the paint. It was left to a Sicilian painter, *Antonello da Messina* (1430–79) to borrow the Flemish idea of painting in oils and bring it home to Italy—or so it's said: there may have been others. It looks like he picked up the idea by studying Flemish painting no farther away than Naples, but nevertheless he made it his own. By 1475 he was in Venice, with a

Chiaroscuro

The contrast of light and shade became known as "chiaroscuro"—a mixture of the Italian words for light and dark. It wasn't the kind of thing you found much before Leonardo and Raphael. Afterwards, chiaroscuro was used almost everywhere (Caravaggio and Rembrandt were keen on it).

1436 *Della pittura* by Leon Battista Alberti establishes the basis of art theory and mathematical perspective.

1449 Scientist Ulugh-Beg uses a curved device more than 130 feet long set on iron rails to catalog more than 1000 stars. His tables are so precise that his calculations of the annual movements of Mars and Venus differ only slightly from modern figures.

1468 The Spanish plant rice at Pisa on the Lombardy plain, the first European planting of rice outside Spain.

1430~1570

Blue Skies
The love of landscapes

Medieval pictures tended to have expensive, gilded backgrounds, and when there were natural settings edging forth from behind the people in the paintings, they tended to be the usual stock smattering of rocks and stones. Europeans weren't like Chinese or Japanese artists, with their appreciation of landscape. Then along came northern artists like Jan van Eyck (see page 46), and suddenly the gardens and views in the backgrounds—although still imbued with symbolic meaning—were sumptuous enough to be good to look at for their own sake, rather than as some kind of theological map.

Peasant Bruegel
Pieter Bruegel (c.1525–69), the greatest northern landscape painter, wandered through Italy in 1552-3 and spent his career painting satirical pictures of rustic country life. His interest in country scenes earned him the nickname "Peasant Bruegel," but it's now thought likely his peasants are erudite references to Greek and Roman satires.

I n Van Eyck's *Madonna with Chancellor Rolin* (c. 1435)—a portrait of power and ownership—you can see Rolin chatting happily away to the Virgin and child, as if they were houseguests, and behind them a beautiful view of mountains, bridges, cities,

Piero di Cosimo's *Forest Fire* (c. 1488): lots of action, fantastic imagination, but no human beings in sight.

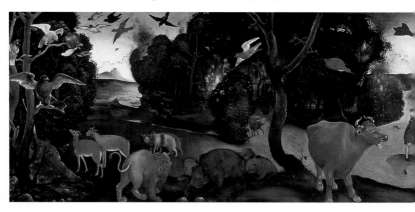

1486 John II of Portugal proclaims himself Lord of New Guinea.

1506 Christopher Columbus dies in obscurity at Valladolid aged 55. His bones are later moved to Santo Domingo.

1530 German mathematician Gemma Frisius suggests that accurate mechanical clocks be set to the local time of a prime meridian to give a standard time for the measurement of longitude.

Altdorfer's *Landscape with a Footbridge* (c. 1518-20) was the first pure landscape painting, without any animate subject at all, although still evoking powerful emotion.

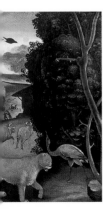

palaces and nature. But artists also realized that landscapes in pictures create moods. *Piero di COSIMO* (c. 1462–1521), in his *Forest Fire* (c. 1488) gives the starring role to animals (he was a strange character who lived on hard-boiled eggs, so they say). Soon Leonardo da Vinci (*see page* 76) set to, with his drawing *Arno Valley* (1473).

NAMES IN THE FRAME

Don't forget the Antwerp connection: like **Joachim Patenir** *(d. 1524), whose* Landscape with St. Jerome *(1515) might as well have done without St. Jerome entirely. The Dutch painter* **Dieric Bouts** *(c. 1400–75) was one of the first to use landscape to enhance the tone. He painted on linen using pigments mixed with glue, which gave a kind of soft-focus effect—as in* The Entombment *(c. 1450–60).*

and peacocks stretches into the distance. The first picture of a recognizable place was *The Miraculous Draft of Fishes* (1444) by the Swiss German painter *Konrad WITZ* (1400/10–44/6), which clearly showed the shores of Lake Geneva.

Petrarch (*see page* 20) started the interest in the countryside for its own sake, and soon the Italians were longing for country

But it was the artists of Antwerp and Venice (Bellini, Giorgione, and Titian) who would lead the landscape revolution. And it was a revolutionary German, *Albrecht ALTDORFER* (c. 1480–1528), who first dared to paint a picture with no creatures—his *Landscape with a Footbridge* (c. 1518–20).

1439 In Benin despotic new ruler Ewuare (who has killed his brother, the previous ruler) orders all free-born citizens to be scarred with facial markings as "slaves of Oba."

1449 In France Gilles de Laval, seigneur de Rais, is executed at Nantes after it is found that this respected knight secretly modeled himself on Caligula and is guilty of more than 200 infant murders and acts of torture.

1450 English nobles enclose more lands to raise sheep, at the expense of the peasantry.

1434~1492
Filthy Rich
The Medicis

Orange balls
The presence of orange trees in at least one painting by Botticelli may be a subtly obsequious reference to the Medici coat of arms, with its five round orange *palle* ("balls"). Wise move.

Florence was one of those strange places, like Hollywood, perhaps, where wealth brought you more status than noble ancestry. That isn't unusual these days, of course, but it was in the 15th century. No family exemplified this more than the Medicis, who emerged from obscurity as successful bankers in the 13th century. From the day in 1434 when the brilliant and subtle Cosimo de' Medici (1389–1464) returned from exile, their rise as wealthy rulers of the city seemed inexorable.

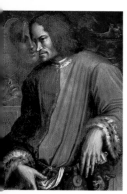

Lorenzo the Magnificent, painted by Vasari after his death, looking serious and dignified.

Cosimo was never so crude as to take power himself. He just pulled the strings, like a mafia boss, and his astonishing political ability prompted his colleagues to give him an increasingly prominent role in city negotiations. Meanwhile, he was keeping himself busy founding libraries, supporting Donatello (*see page* 36), and commissioning Michelozzo (*see page* 51) to design his Palazzo Medici (1444).

But it was his grandson, *Lorenzo the MAGNIFICENT* (1449–92), who saw the full flowering of Medici power and patronage of the arts in Florence (although Lorenzo

c1460 In China the imperial porcelain works at Ching Te Chen export Ming pottery for the first time.

1464 Florence's Cosimo de' Medici dies aged 75 while listening to one of Plato's *Dialogues*.

1481 In Japan peasant communities revolt against excessive taxation and the power of the moneylenders.

wasn't really up to it when it came to business, and the family bank suffered under his control). Lorenzo commissioned works by the next generation of artists—Botticelli and Michelangelo—and he encouraged those around him to commission art, too. He also led the growing taste for country life, which was reflected in the new flood of pictures with country views in the background, and in Botticelli's renditions of strange rustic rituals and springtime rites (*see page 68*). Lorenzo got the Pope to make his son Giovanni a cardinal in 1489 and he went on to cement the family fortunes as Pope Leo X (*see page 106*).

NAMES IN THE FRAME

Lorenzo de' Medici was also an accomplished love poet, and used his talents to spread his new gospel of spring, fertility, and rural life, much like the other poets of his circle such as **Angelo Ambrogini de Poliziano**, *also known as Politician (1454–94). This is Lorenzo in full flight: "Wherever my lady turns her beautiful eyes, with no other sun does this new Flora cause the earth to germinate and to put forth the thousand various colors of the new flowers."*

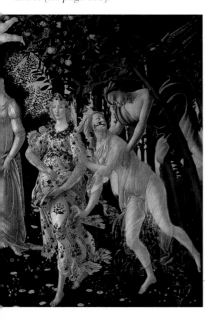

ENFORCED EXILES

The death of Lorenzo led to the takeover of Florence by the monk Savonarola (*see page 52*) before it became a republic again, and the family was twice forced into exile before returning as the hereditary Grand Dukes of Tuscany. The republican heroes who had laid the foundation of the highly successful Renaissance culture of Florence slipped gently into the European aristocracy until the political convolutions that lay a little over two centuries ahead.

Botticelli's mysterious *Primavera* (c. 1477), commissioned by Lorenzo de' Medici, is a perfect example of Botticelli's fixation with rustic rituals and springtime rites.

1440 Cosimo de' Medici institutes a progressive income tax to alleviate the burden on the poor of Florence who support the Medici family.

1441 The Duchess of Gloucester admits charges of dealing with sorcerers and is sentenced to public penance and life imprisonment.

1453 The fall of Constantinople increases the need for sea routes to Asia because Muslim rulers impose high tariffs on caravan shipments with the highest duties levied on spices.

1439~1478

Getting Things in Proportion
Piero della Francesca

Have you ever thought of measuring yourself a painting? The new mathematics became so compelling for some Renaissance artists that they gave up art altogether to concentrate on calculation. That decision was probably helped along for Piero della FRANCESCA (1410/20–92) by the little matter of going blind. But even so, by late middle age, Piero had become so fascinated by cubes, tetrahedrons, and dodecahedrons, that he gave up art for measuring tape.

Math

Piero was friends with two of the great Renaissance mathematicians, Alberti *(see page 50)* and Pacioli *(see page 92)*, and wrote two great treatises on math—before dying just about the same time as Columbus was leaving for the New World.

In 1450, just before the fall of Constantinople, a delegation of its leaders came on a desperate visit to Florence to ask for help, and processed through the streets in their strange, colorful eastern garb. Piero saw them and never forgot the sight. He was to reproduce their beautiful robes and peculiar headgear in picture after picture for the rest of his life.

But it was geometry that really excited him. Alberti *(see page 50)* introduced the idea of exact proportions in the human form. Dürer *(see page 94)* later introduced exact proportions for letters. But it was Piero, who spent much of his time as town councillor in his native Borgo San Sepolcro, who applied the idea of proportion to the picture as a whole.

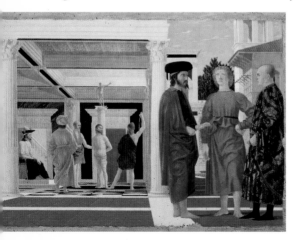

Piero della Francesca's mysterious *Flagellation* (1450s): all the figures are perfectly proportioned and in perspective, but the real action is in the background.

1454 Twenty-eight French musicians perform inside a huge pie at the Feast of the Pheasant for the Duke of Burgundy, Philippe le Bon.

1460 James II of Scotland is killed when a cannon bursts while he is besieging Roxburgh Castle in sympathy with the Lancastrian cause.

1468 Norway surrenders the Orkneys to Scotland; they'd already handed over the Shetlands in 1462.

COUNTING BLOCKS

Take his bizarre painting *Flagellation* (1450s), where a peculiar bunch of passers-by occupy the foreground, while Christ is in the distance being whipped. It's a strange reversal of the usual order of things, but it is all precisely measured, using Piero's trademark brown tiles all over the floor, with the perspective calculated exactly. It's all a pale reflection of divine proportions, just as the neo-Platonists wanted. Or failing that, it's a precise way of working out how many carpet tiles they might have needed. Piero gets his rather

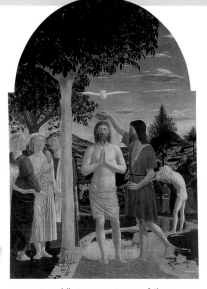

Piero della Francesca's *Baptism of Christ*
(1450s) now in London's National Gallery.

NAMES IN THE FRAME

Piero is fashionable these days, but in his own lifetime his art was regarded as rather a dead end—though he certainly influenced Bellini and Raphael. And he did paint what was probably the first night scene in Western art— The Dream of Constantine. *His pupils, however, were very influential:* **Pietro Perugino** *(1445/50–1523), with his quietly sentimental, pious frescos, and* **Luca Signorelli** *(1441/50–1523) with his cruel, passionate paintings.*

lumpen figures from Masaccio (*see page* 42) and his beautiful pale colors from his teacher *Domenico VENEZIANO* (d. 1461), but the proportions he took from the 6th-century BC mathematician Pythagoras.

In Piero's *Baptism of Christ* (1450s), Christ is in the exact center, and he's precisely half the height of the painting. And the whole thing is composed on the basis of Euclid's 15-sided polygon. It all goes back to the divine harmonics of numbers that, according to Pythagoras, lay behind art and music. It was Pythagoras who famously realized there was harmony in numbers by listening to the different notes made by a blacksmith's anvil.

1450 Pope Nicholas V endorses the practice of slavery.

1467 Sesshu, the Japanese Zen priest and landscape painter, and Shubun, a Chinese painter who became a naturalized Japanese, work to bring Chinese and Japanese art closer together.

1469 In Florence the complete works of Plato are translated into Latin by priest Marsilio Frurio under Medici patronage.

1447~1527

Marble Halls
The revival of Rome

Rome in the bad old days.

We think of Rome these days as either the center of an empire or the "eternal city" of magnificent papal palaces and Renaissance art. But in the 14th and 15th centuries there seemed precious little eternal about the place. The popes had left in disgust and gone to live in Avignon. The complete failure of the city government to repair the roads had cut the city off from trade or manufacture, and the brutality of the local mobsters was notorious throughout the western world. Its population had shrunk to just 25,000.

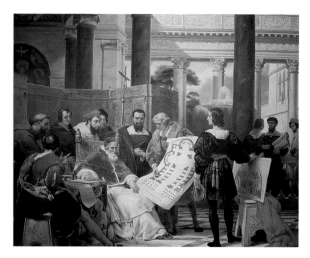

An indolent-looking Julius II ordering the building of the Vatican and St. Peter's: as painted in this 18th-century reconstruction by Vernet.

Then in 1447, along came Pope Nicholas V (reigned 1446–55), with a determination to revitalize the city. His immediate predecessors had made a start. Pope Martin V (reigned 1417–31) had summoned the assistance of the greatest artists, Gentile da Fabriano, Masolino, and Masaccio (who even died there). But it was Nicholas who entrenched the changes, sketching out the first plans and giving tax concessions on building for wealthy cardinals. He dug up the ruins of ancient Rome that so inspired the contemporary artists, and then made use of both the artists and the ruins in grand new buildings.

1477 John Stacey and Thomas Burdett are executed for trying to kill King Edward IV by necromancy.

1507 The Portuguese capture Zafi in Morocco and begin the white slave trade with captive Moors, Berbers, and Jews, many of whom are women.

1525 Zech of Prague develops the "fusee," a wire attached to a spring that will prevent clocks from losing time.

DRAWING IN THE TALENT

Soon followed Pope Julius II (*see page 106*), who commissioned the greatest artists of the age. There was the young Raphael, working on a stable block at the Villa Farnesina (1508–11) that was more luxurious than most palaces, and the architect Donato Bramante (*see page 80*) sketching out the 1506 plans for the new St. Peter's. Julius had demolished the old Basilica that was supposed to stand over the grave of St. Peter himself, which had stood crumbling since the reign of Constantine the Great in A.D. 324. It wasn't to be finished for another 120 years.

But even when Rome was at its lowest ebb, the remains of the ancient city were still

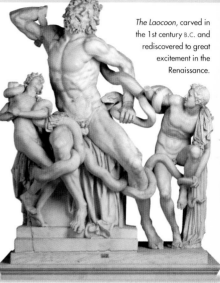

The Laocoon, carved in the 1st century B.C. and rediscovered to great excitement in the Renaissance.

Fire!

The burst of artistic revival in Rome came to a temporary halt in 1527 when French troops burned parts of the city and the new Roman artists had to escape for their lives.

proving inspirational to the artists at the forefront of the Renaissance, as they wandered among the ruins and imagined what it must have been like. Among them was Lorenzo de' Medici's favorite architect *Giuliano Sangallo* (c. 1453–1534), who drew it all, made models, and then created some of the first villas around a central hall, prefiguring Palladio's work next century (*see page 134*).

NAMES IN THE FRAME

Rome was also no longer the heart of the Christian world. The crusades had failed, Constantinople had fallen to the Muslims in 1453, and the great traders of Venice preferred to do business with the Muslims than to fight them. Machiavelli (see page 116) even praised Turkish rule as an example of expert political organization. The power of trade and money had beaten the old powers of religion and tradition into submission.

1460 Venice completes its Arsenale. Almost a town within a town, it includes a large shipyard for building the vessels that provide the republic's wealth and power.

1463 French poet François Villon narrowly escapes hanging after a last-minute pardon is granted.

1468 An actor in Metz dons cardboard breasts filled with pigs' blood to make the murder scene more dramatic.

1450~1516

Underneath the Arches
Bellini

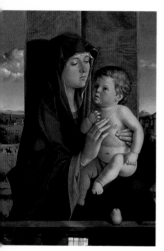

There was a sudden moment in the career of the painter and draftsman Jacopo BELLINI (1400–70/1) when he embraced enormous vistas and bizarre classical detail—such as the engulfing arch that dominates Christ Before Pilate (c. 1455). There was a reason for this. In 1453, his daughter Nicolosia had been betrothed to and later married the archaeologist-painter Mantegna (see page 70). And so it was that classical arches hovered in the background of many of the paintings of the Bellini family ever afterward.

Giovanni Bellini's *Madonna and Child with Pear* (c. 1480–90): he provided varying madonnas as required by his clients.

Not all, of course. Because Jacopo's son *Giovanni* (c. 1430–1516) was one of the pivotal figures of the Italian Renaissance. He's known for the lessons he learned from the Netherlands painters, for his use of oils, his colors, his sense of light binding it all together, and for his three-quarter length paintings—take a look at his *Lady at her Toilet* (1515). He was also known for going on and on and on, mostly as chief painter to the Venetian state—churning it out for well over half a century. As late as 1506, Dürer (*see page 94*) wrote home that Bellini was "very old, but still the best in painting."

THE REINVENTION OF BELLINI

By the end, he had been chief painter for nearly 30 years, fighting off all attempts to get him out—including the efforts of Titian—and producing those famous portraits of the Doges. See, for example, the smug and peculiar Doge Leonardo Loredan

TECHNO BOX
Bellini's speciality was madonnas. He painted them from the start of his career, and in all of them he experimented with new ways of representing light, just as Leonardo—far away in Florence—was trying out similar methods. A good example is his *Madonna and Child* (c. 1480), now in the Burrell Collection, Glasgow.

1494 The "French pox" (syphilis) arrives in Europe for the first time.

c1500 Trawyas, wooden tracks for trolleys to run along, are used in mines.

1510 Leonardo da Vinci designs a horizontal waterwheel that is an early precursor of the water turbine.

(c. 1501). looking a little like something out of *Star Trek*. He was also reinventing himself as a painter of mythological works, such as *Feast of the Gods* (1514), as he slowly came to terms with a new century that brought with it Michelangelo and the star performers of the High Renaissance.

Many of the best names, including Giorgione and Titian, had been his pupils. But in fact he had been in place for so long that almost nothing in Renaissance art had escaped his influence—a bit like the long-lived Titian himself a couple of generations later. The point is that Giovanni Bellini

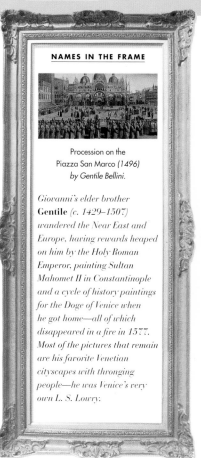

NAMES IN THE FRAME

Procession on the Piazza San Marco *(1496)* by *Gentile Bellini.*

Giovanni's elder brother **Gentile** *(c. 1429–1507) wandered the Near East and Europe, having rewards heaped on him by the Holy Roman Emperor, painting Sultan Mahomet II in Constantinople and a cycle of history paintings for the Doge of Venice when he got home—all of which disappeared in a fire in 1577. Most of the pictures that remain are his favorite Venetian cityscapes with thronging people—he was Venice's very own L. S. Lowry.*

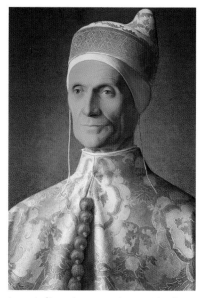

A portrait of Leonardo Loredan (c. 1501), the Doge of Venice from 1501–21: what you might call one of Giovanni Bellini's *Star Trek* paintings.

lived at one of those crucial meetings of time and place—history and geography—that made Venice what it was: a place where gold icons from Constantinople, oil paintings from the Netherlands, and revolutionary techniques from Florence could all come together in a Big Bang.

1453 English composer John Dunstable dies. His motets, chansons, and settings of sections of the Mass have contributed greatly to the development of Renaissance music.

1483 The Little Princes are murdered in the Tower of London and some say Richard III is responsible.

1498 Vasco da Gama of Portugal reaches India having discovered a sea route from Europe to the subcontinent.

1450~1600

Gentlemen of the Press
The rise of printing

Could they have held a Renaissance without the invention of paper? It would have been tough, writing everything on cloth, and only painting on walls or canvas. But supplying the prosperous new middle classes with all the books they wanted would have been a downright impossibility. Luckily, the art of paper-making had arrived in western Europe in the 12th century, and the skills required to make it were becoming increasingly widespread. By the time Michelangelo was shinnying up his ladder, there was paper everywhere.

The beginnings of deforestation.

The Gutenberg Bible (1455): first in a long line of heavyweight instructional tomes.

A plentiful supply of paper meant that more people could express themselves, read the classics and become the audience for the revolution happening all around them—but above all, they could read books.

Enter *Johann GUTENBERG* (c. 1400–68), probably the first European to start using moveable type. Historians still argue about whether he was really the first—there are rival candidates from most European countries and Gutenberg's name doesn't appear in any of his books. Even so, Gutenberg certainly started early, training as a goldsmith—like so many of the Renaissance pioneers. And around 1455,

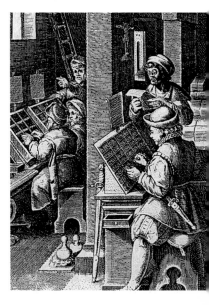

1501 A spectacular pageant is held to celebrate Catherine of Aragon's arrival in London. She marries Arthur, Prince of Wales, but he dies and in 1502 she is espoused to his 11-year-old brother Henry.

1531 Sugar becomes as important as gold in the Spanish and Portuguese colonial economies.

1600 Smugglers break the Arabian monopoly in coffee beans by taking seven seeds of unroasted beans from the Arabian port of Mocha to the western Ghats of southern India.

his new press in Mainz started churning out the famous Gutenberg Bible. In the end, though, Johann was to lose the business in a legal battle with his partner.

German printers took the idea to Italy, and the idea spread quickly across the continent. Italians took to it like a duck to water, specializing in Greek and Latin books. The first press appeared in Venice in 1469. In just over 30 years, there were 417 printers in that city alone, with Paris just behind. By 1539, the first printing press was up and running in America, thanks to Juan Pablos in Mexico City.

Free knowledge, the Bible in ordinary language, new humanist education—it was a heady combination that spread the ideas

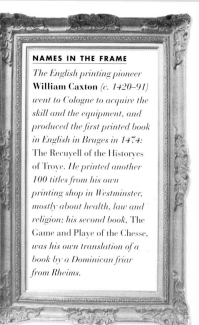

NAMES IN THE FRAME

The English printing pioneer **William Caxton** *(c. 1420–91) went to Cologne to acquire the skill and the equipment, and produced the first printed book in English in Bruges in 1474:* The Recuyell of the Historyes of Troye. *He printed another 100 titles from his own printing shop in Westminster, mostly about health, law and religion; his second book,* The Game and Playe of the Chesse, *was his own translation of a book by a Dominican friar from Rheims.*

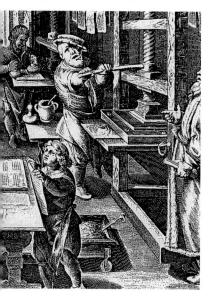

of the Reformation like wildfire across Europe. By the 1540s, forbidden books were being circulated in Italy—Pope Paul IV's Index of 1559 meant that the church authorities were beginning to censor books if they were deemed heretical or immoral—including works by the key Renaissance authors such as Machiavelli, Luther, and Boccaccio (*see pages* 116, 122, and 20). But by the end of the century, Italy was losing its printing preeminence to Paris again. The Renaissance was over.

A depiction of an early printing press, showing printer's apprentices searching through the boxes of letters, which were formed from metal.

1461 In the Wars of the Roses, 28,000 men die at the bloody Battle of Towton.

1484 The importance of heraldry is recognized in England with the forming of The College of Arms.

1487 In Dublin, imposter Lambert Simnel is crowned Edward V of England.

1460~1510

Flower Power
Botticelli

Imagine you are at a Medici pageant in one of their country palaces. You are surrounded by the nouveau riche—but you must remember that these are the people who are taking a lead in the creation of artistic taste. There is music, poetry, and a great deal to eat, but there's something else as well—something your parents might have warned you against—a slightly unhealthy obsession with flowers, seeds, fertility, and scantily clad young people in tune with nature. Is this Woodstock 1469? No. You have stumbled upon the Renaissance discovery of rustic mythology, and you are looking at the mainspring of the genius of the painter Sandro BOTTICELLI (1445–1510).

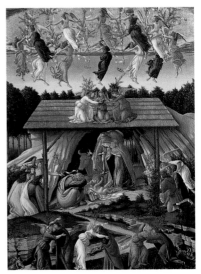

Sandro Botticelli's ornate and slightly hysterical *Mystic Nativity* (1500), complete with angels: art historians wonder whether it drove him mad.

The "in" crowd
Take a look at Botticelli's *The Adoration of the Magi* (c. 1475), where the whole Medici court of the day seems to have turned up at the same time as the Magi and their hangers on—with their servants apparently unconcerned about the action at the center. And there is Botticelli himself in an orange robe, looking out of the picture at us.

Art historians have never quite sorted out Botticelli's career. He learned at the feet of *Filippo Lippi* (*see page* 48), and in turn taught Lippi's illegitimate son *Filippino LIPPI* (1457/8–1504). It looks as if he worked side by side with Leonardo da Vinci (*see page* 76) under Donatello's other pupil, the sculptor *Andrea del VERROCCHIO* (1435–88). But in what order did he produce his paintings? The Victorians thought he graduated toward realism, as in *Fortitude* (1470), but actually it now looks as if this was where he started—and in the

1500 Goldfish are exported to Japan from China.

1502 Columbus discovers Nicaragua.

1505 Thomas Tallis, the English organist and composer, is born. His career will span the reigns of four monarchs.

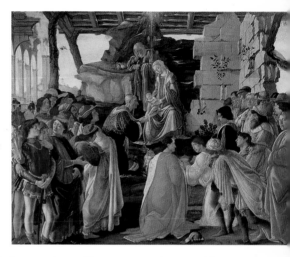

Botticelli's *Adoration of the Magi* (c. 1475): the man on the right is said to be the artist.

end it was to culminate in the rather hysterical religious ecstasy of *Mystic Nativity* (1500).

PAGEANTRY

The world-famous *Primavera* (*see page* 58) borrows straight from the classical tradition, but sets the Three Graces with Cupid, Venus and Mercury, and a zephyr under an orange grove—a reference to the Medici emblem—with flowers on their dresses and, in one case, pouring out of her mouth. It could even have been a painting of a Medici pageant, with Lorenzo de' Medici off-stage, presiding over it all.

Flower power and strong outlines went out of fashion in the age of Michelangelo and Leonardo, when Botticelli was an old man, and there is some evidence that the religious crises that produced *Mystic Nativity* also sent him mad. Nobody knows much about the last ten years of his life.

His great pictures are full of symbols that are peculiar mixtures of Christian and pagan. Check out his even more famous *Birth of Venus*, along with *Primavera*, in the Uffizi in Florence.

NAMES IN THE FRAME

Some of the Botticelli and Filippino Lippi paintings now in London weren't their work at all, according to the great Renaissance expert **Bernard Berenson** *(1865–1959)—but by a friend of theirs whom he called "Amico di Sandro." Both artists ran large studios, but most art historians don't believe in Amico's existence any more, and are pretty certain that the pictures in the National Gallery are absolutely genuine.*

1466 Florence's Luca Pitti fails in an attempt to assassinate Piero de' Medici and is stripped of his powers.

1492 Martin Behaim, German mapmaker, creates the first globe.

c1500 The first violins are made.

1464~1532

Marble Bodies
The Lombardo family

Getting that fold just right.

They did love their classical antiques, didn't they? But despite all the efforts of Renaissance sculptors to capture the magic of the classics, much Renaissance art was still recognizably of its own time. Then along came a family of sculptors whose evocation of flowing robes and sedate Roman faces looked as if they could really have been Roman—except for the fact that they tended to be portraying saints on Christian tombs.

W hy bother, if all you're doing is just copying the classics? You might well ask. The Lombardo family were living in an artistic climate still heavily influenced by archaeology, ruins, and the work of the great painter-archaeologist Mantegna (*see page 31*), and their Venice workshop made a good living churning out tombs and statues. They were among the first who really looked at what the archaeologists were digging up and integrated it into Venetian art—at a time and place when most art was a fine balancing act between Byzantine and classical traditions.

Pietro LOMBARDO (*c.* 1435–1515) turned up for the first time in Padua in 1464, working on the Roselli tomb (1467). Soon he and his sons *Tullio* (*c.* 1455–1532) and *Antonio* (*c.* 1458–1516) were hard at work in Venice chiseling out their thick-set Roman figures. The Mocenigo tomb and

Tullio Lombardo's version of a classical satire (1481): a figure on Andrea Vendramin's tomb.

the tomb of the Doge Andrea Vendramin in SS Giovanni e Paolo in Venice (1481) and Dante's tomb in Ravenna all have good examples. And there's Pietro's statue of Adam—now separated from Eve and the Vendramin tomb where it was originally placed, today residing in the Metropolitan Museum of Art, New York.

1509 Henry VII of England dies and there is much feasting, dancing, and general rejoicing.

1521 Ferdinand Magellan claims islands in the Pacific that will later be called the Marianas. Magellan calls them Islas de los Ladrones (Islands of Thieves) because the natives steal from his ships.

1532 The Holy Roman Emperor Charles V establishes residence at Madrid and pays for improvements to the imperial palace with taxes on Caribbean sugar.

Tomb sculptures

Having one of the new classical sculptures on your tomb was becoming increasingly fashionable in the Renaissance, but not in the old medieval style of an identikit dead or sleeping figure. Renaissance tombs were beginning to carry recognizable portraits of the person inside, often looking as though they were still alive. The culmination of this is Michelangelo's rendition of Giuliano de' Medici sitting on his tomb, thinking deeply.

BEYOND THE CLASSICS

The Lombardo sons were even more classical and dramatic than their father, and their work paved the way for the sculpture of the High Renaissance, and the even more dramatic flourishes of Raphael and Giorgione.

But then, Renaissance sculpture never was about just copying the classics. It was about seeing how the classical sculptors managed it, and attempting to borrow some of their authority. It felt a bit lonely and vulnerable, being a republic in those days. There was Florence and Venice—but virtually nowhere else. So if they could borrow a bit of that classical authority from the great republics of ancient Greece and Rome, then maybe they could feel they had more status when they encountered kings and emperors whose lands surrounded them.

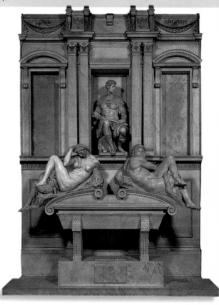

Michelangelo's version of a classical tomb (1520–34), for Giuliano de' Medici, brother of Lorenzo the Magnificent.

NAMES IN THE FRAME

Antonio del Jacopo Benci Pollaiuolo *(c. 1432–98) was one of the first Renaissance artists to take his eye off the classical models. He dissected a human body, just to see how it was put together, and you can see the extraordinary results of his research in* Hercules and Antaeus. *Pollaiuolo was also responsible for the famous painting of* The Martyrdom of St. Sebastian *(1475), a joint effort with his brother* **Piero** *(c. 1441–96).*

1477 The body of Charles the Bold, Duke of Burgundy, is found two days after the battle of Nancy, half-eaten by wolves.

1484 Henry VI's body is removed from Chertsey Abbey. It is said that his face is "somewhat shrunken, with a more meagre appearance than ordinary."

1494 Spain and Portugal sign a treaty dividing all newly discovered lands between them along with any others that may be discovered in the future.

1470~1516

Animal House

Bosch

It's a world of fish-men, pig-jars, frog-horses and souls in the torment of hellfire, yet even as upright and orthodox a holy man as PHILIP II OF SPAIN (1527–98) could have the paintings in his bedroom.

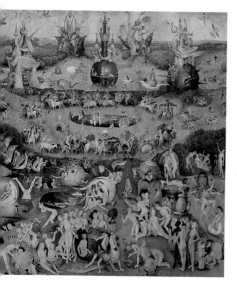

The trouble is that it's probably impossible to know these days exactly what Hieronymus BOSCH (c. 1450–1516) wanted his bizarre representations of the world to convey—but they remain some of the most potent fantasy pictures ever painted. And contemporaries like Philip II may have known immediately what they meant.

The Garden of Earthly Delights (c. 1500): Bosch's bizarre vision of demons and monsters in half-human, half-animal form, now in the Prado.

TECHNO BOX
Bosch was extremely influential after his death. There was a major Bosch revival in the 1550s, which had a great effect on Pieter Brueghel (see page 56), but he was probably most influential in his painting method. This was known as *alla prima*, and entailed painting straight on top of a dark brown color.

Were they obscure subversive or heretical codes that we simply can't decipher any more, as some historians have said? Or were they just unorthodox ways of looking at conventional religious ideas, such as the mortality of humanity—as seems more likely? Twentieth-century critics have hailed him as an early Freudian, but to us his paintings look more like imaginative warnings against the perils of genetic engineering. Even in the 15th century, Bosch was in a class of his own. He took the most bizarre and horrific details from local life in the Netherlands—maybe his home town of Hert'sogenbosch—and turned them into something eternal.

1500 The claymore, or two-handed sword, comes into use in the Scottish Highlands.

1509 Sebastian Cabot leads an expedition to search for the Northwest Passage to Asia but ice forces him to turn back to Hudson Bay.

1511 In Britain, all men under the age of 40 are required to possess bows and arrows and practice archery.

PIGS AND FISH

On the other hand, he does fit into a tradition. He was using the new artistic techniques of the Renaissance to usher out the Middle Ages, with all its hellfire and horror, once and for all. And he was obviously learning from his Flemish forebears, Bouts and Weyden (*see page 47*), about painting landscapes. It was just that Bosch knitted it all together with a bizarre agenda all of his own, involving peculiar combinations of pigs and fish. He was also probably producing the same kind of satires on human folly and sin that Erasmus and the other humanists were writing about.

NAMES IN THE FRAME

Don't miss Bosch's Dutch contemporary **Geertgen tot Sint Jans** *(d. 1485/95), who—like Masaccio—seems to have started as a brilliant artist in his twenties, only to expire unexpectedly at the age of 28. Also like Masaccio, there has been comment about the strange shape of the figures he painted—they have odd egg-shaped heads. Two massive works that are probably his hang in the Kunsthistorisches Museum in Vienna.*

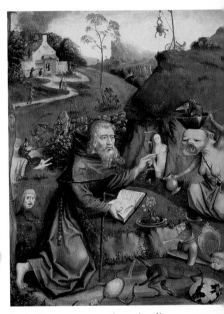

Bosch at his most peculiar: *The Temptation of St. Anthony* (c. 1500), with a number of his trademark creatures. Was he an early Surrealist?

Nobody knows about his early years. We don't know who taught him, or if he ever visited Italy to see the Renaissance masters. We don't know in what order he painted his pictures—but a rule of thumb seems to be that the more tiny figures there are wandering around in the foreground, the later they were painted. And if you want to see a work of Gothic horror by someone who clearly lived on the edge of it, the precursor of everything from *The Lord of the Rings* to *The X-Files*, you can't go far wrong with Bosch.

1478 The Duke of Clarence is condemned for treason and dies in the Tower of London; he allegedly drowns himself in a butt of malmsey wine in order to avoid the public spectacle of his execution.

1500 Pancelus, the last alchemist, discovers hydrogen. He is also a medical reformer who believes that disease is introduced to the body by external agents rather than being caused by an imbalance of humors.

1513 Vasco Nunez de Balboa finds the Pacific Ocean.

1470~1540

Doges and Damp
The rise of Venice

What was it that gave Venice such a magical air during this period? It was the canals, of course, and that strange mixture of sacred and degraded humanity that remains so perversely appealing today. But it was also the sense of peace and civilization you got there. Contemporaries put it down to three crucial advantages—stable republican rule, a sense of tolerance, and a bizarre but successful constitution that never seemed to change.

NAMES IN THE FRAME

The Lombardo family brought Renaissance sculpture to Venice and Bellini infected the city with enthusiasm for classical painting, while Venetian painter **Antonello da Messina** *(c. 1430–79) introduced the Italians to Flemish oil painting techniques. He was among those painting* sacra conversazione—*basically pictures of New Testament figures chatting, which used perspective to pretend the picture was an extension of the room it was displayed in.*

Sansovino's Golden Stairs (1554–56) lead up to the Doge's palace.

This constitution tried to make sure that nobody with too much ambition was permitted to become "Doge," ruler of Venice. The republic was run by a Council of Ten, elected—by labyrinthine methods —from the list of 200 aristocratic families who had a hereditary right to sit on the Venetian Great Council.

Venice also had a great sea empire, which gave it a cosmopolitan atmosphere of trade and modernity. Positioned on the border between East and West, it was gathering-place for a unique mixture of Europeans, Turks, and merchants and visitors from far-off lands. But the proximity of the sea had another effect— frescos tended just to dissolve in the sea air, which is why Venice was one place where the Italians pioneered oil painting. They had to, if they wanted their great historical paintings to last.

1532 Francisco Pizarro introduces horses into Peru.

1534 *Gargantua* by François Rabelais satirizes French theologians, scholasticism, politics, and manners.

1540 Waltham Abbey in Essex, the last of the great monastic houses, is seized by agents of Henry VIII.

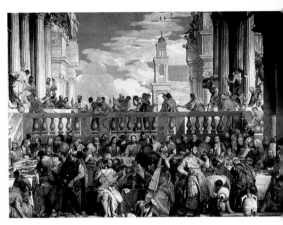

The Marriage at Cana (1563) by Veronese, actually a portrait of contemporary Venice.

Venice acquired Cyprus in 1489 and built up a formidable mainland empire during the political wars in Italy between 1494 and 1530. That wealth and stability, not to mention those Venetian ducats—one of the strongest currencies you could get—attracted artists from all around. One of them was the great architect *Jacopo SANSOVINO* (c. 1486–1570), who fled to Venice after the Sack of Rome in 1527, and built the great library of San Marco (1537–88) that Palladio described as "probably the richest building ever built."

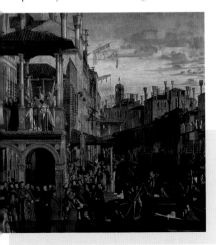

SENSE OF OCCASION

Opposite the library was the Doge's Palace, built in an ornate Gothic style throughout the 14th century, and shortly to be decorated by the great Venetian artists Titian, Tintoretto, and Veronese (*see pages* 118 and 130), with stairs by Sansovino.

Look for the Venetian passion for history in their paintings, and their sense of occasion and colorful celebration—all squeezed onto gigantic canvases. If you want an example, Veronese's painting *The Marriage at Cana* (1563) is a good one.

Carpaccio

Check out Vittore Carpaccio (c. 1460/5–1523/6), one of the great Venetian history painters and assistant to Giovanni Bellini. Some experts say that his *Knight in a Landscape* (1510/26) is the first full-length portrait ever painted.

Carpaccio's contemporary view of the Grand Canal (1494).

1486 In Rome Pico della Mirandola's "Conclusiones," humanist writings on God and man, are condemned as heretical by Pope Innocent VIII.

1496 A naval dockyard is established at Portsmouth by King Henry VII.

1501 The first African slaves are imported to America.

Restoration

In 1999, the restored *Last Supper* by Leonardo da Vinci was unveiled after intricate work to regain its former glory had been undertaken, inch by inch, since 1977. It ran into immediate controversy, after critics objected to the "technicolor" additions made by the restorers to blank parts of the picture.

1472~1519

Smoke and Smiles
The great Leonardo da Vinci

If you aspire to being one of the greatest artists in history, in an age of supermen, then it helps if you look a little like God. LEONARDO da Vinci (1452–1519) did, but he also had something else: genius at a frighteningly early age. When he began his career in Florence as an assistant to the painter Andrea del Verrocchio (see page 31), he painted a small angel in the corner of one of his master's paintings. He did it so beautifully, or so it was said, that Verrocchio gave up painting there and then in despair and henceforth stuck to sculpture instead.

A Leonardo self-portrait (1513): a doppelgänger for God.

But then, Leonardo was one of the most astonishing people of all time—artist, sculptor, scientist (*see page 82*), physiologist, engineer, musician, and pioneer inventor. He was restless, dissatisfied, and difficult, moving from one painting to the next without finishing the last one, all the time tortured by his secret and heart-rending loves.

Being Leonardo da Vinci was a difficult business. He spent his most productive years locked in bitter rivalry with Michelangelo (*see page 84*), only to abandon the battlefield—the painting he

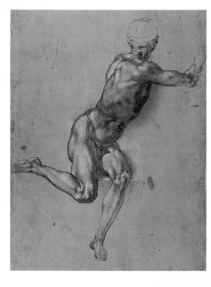

Michelangelo's study for the *Battle of Cascina* (1505), shows their differing styles—Michelangelo's firm-lined physicality versus da Vinci's softer style.

1512 The English Parliament forbids the importation of foreign caps.

1515 The 300-foot spire of Louth church, Ireland, is completed at a cost of £305.

1519 Spanish conquistador Hernan Cortès sends a message to Montezuma saying "I and my companions suffer from a disease of the heart that can only be cured with gold."

Leonardo's cartoon of *The Virgin and Child with St. John the Baptist and St. Anne (c. 1499)*, complete with enigmatic smiles.

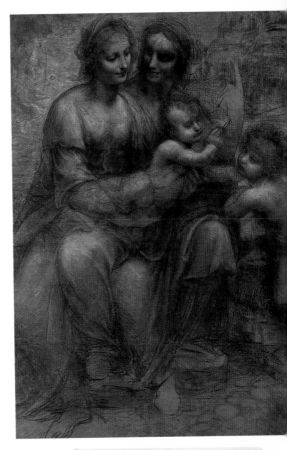

had spent two years on, *The Battle of Anghiari* (1503–6) – because his experimental wall-painting technique wasn't working.

This was an occupational problem for Leonardo. His famous painting on the wall of the Sta Maria delle Grazie in Milan, *The Last Supper* (*see page* 27), soon began disappearing into the wall because of his experimental new method of oil painting.

Still, it was his oil paints that made the biggest impact on his contemporaries, who lined up to stare transfixed at his paintings, looking at the way the colors fed into each other—instead of the usual hard outlines—with the technique which he called "*sfumato*" or "smoky."

When they had done with gawping at the shadowy colors, they marveled at the enigmatic, subtle emotions on the faces, most famously the *Mona Lisa* (*see page* 98) and the "cartoon" of *The Virgin and Child with St. John the Baptist and St. Anne* (*c.* 1499). —all of them portrayed with peculiar smiles as if they know something we don't.

TECHNO BOX

Leonardo's problem, everyone says, was that he was centuries ahead of his time. He couldn't get his head or his technique around his gigantic ambition. Leonardo "envisaged such subtle, marvelous, and difficult problems, that his hands, while extremely skillful, were incapable of ever realizing them," said the great Renaissance interpreter Giorgio Vasari (*see page* 136).

1532 Count Cesare Frangipani in Rome invents the almond pastry that will bear his name.

1538 *Poule d'Inde* ("chicken of the Indies," meaning turkey) is served in France; it will later be called *dinde* or *dindon*.

1540 Dutch whaling captain Jon Greenlander lands in Greenland and finds the last Norse colonist lying dead outside his hut with an iron dagger in his hand.

1475~1600

Simple Sounds
The rise of Renaissance music

The enthusiasm for all things Greek—that is, all things ancient Greek— spread to the world of music rather late. But then, in the heart of the Renaissance in Italy, music wasn't the center of life— that came later. Most choir masters and musicians were foreign, and it was probably France that led the rest of Europe in the musical world, with new songs and composers.

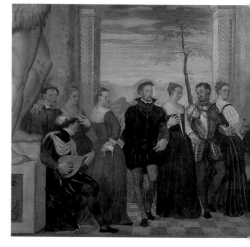

Late Renaissance musicians accompanying nobles on a Sunday stroll: not so much music as muzak.

There was also a big problem about rediscovering Greek music. It wasn't like rediscovering Greek statues. In the case of music, there were absolutely no examples left—all that lingered was a fleeting gut feeling that Greek music was somehow more emotional.

The instruments
Italians tended to be more interested in the words than the instruments, but you would have found the upper classes listening to viols and lutes. Street musicians known as *piffari* produced a cacophony of sound using flutes, recorders, cornets, sackbuts, and trombones.

These were the days of *frottola*, a kind of secular song which flourished in Italy after 1490, and which could be used as a tune for almost any poem or sonnet—and *frottola* slowly evolved into madrigals. But then Renaissance musicians began to develop the idea that if you set words to the most appropriate music, you could produce a far more profound emotional effect. Nobody had really thought of this idea before, although we take it for granted today. It was the musical parallel to all those subtle moods and frowns of the faces in the Renaissance paintings—suddenly feelings were important.

1541 Michelangelo finishes his *Last Judgment* in Rome's Sistine Chapel; it measures 18 yards in length, 10 yards in height, and is the largest painting in the world.

1545 Silver is found in Peru and Mexico.

1566 Mary Queen of Scots' second husband Lord Darnley assists in the murder of her Italian secretary David Riccio because he is jealous of him.

SIMPLY RELIGIOUS

By the 1530s, proper madrigals were beginning to appear in the Netherlands, and for the next two centuries the genre—with its selection of voices singing different parts in the manner of instruments—was the usual musical way in which households would entertain themselves, if indeed music was what they wanted.

But what about religious music? The answer was that there wasn't much of it, beyond the old-fashioned medieval kind. It wasn't until the Council of Trent (1562) laid down that music in church should be simple, and the words of the Mass audible—exactly what the Renaissance humanists thought as well—that the religious music of the Renaissance

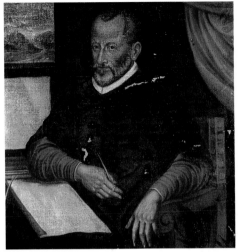

Palestrina: one of those who discovered that the words could be important as well as the music.

started to pour forth from the pens of *Vincenzo Ruffo (c. 1510–87)* and *Giovanni Pierluigi da Palestrina (c. 1525–94)*. Together they demonstrated how music can emphasize the meaning of the words rather than obscuring them in the way it had in the past. Surprising that nobody had thought of that before.

NAMES IN THE FRAME

Maybe the most important musical figure of the Renaissance was **Ottaviano Petrucci** *(1466–1539). In 1498 he got a license to print music and his strange three-stage printing process—one for the lines, one for the notes, and one for the words—started issuing the music for frottolas, madrigals, and church music. Soon the presses of Milan and Rome were following suit, and a sophisticated audience was playing them from the new sheet music.*

1484 In Lisbon the first European manual of navigation and nautical almanac is prepared by a group of mathematicians appointed by King John II of Portugal.

1503 Portuguese caravels return from the East Indies carrying 300 tons of pepper.

1510 The Venetian painter Giorgione (Giorgio da Castelfranco) dies of plague at age 32, having caught the disease from "a certain lady."

Thinking big

They all seemed to love the idea of circular buildings at this stage. Even when he was in Milan, Bramante was knocking them up for the Church of San Satiro and the sacristy for the Santa Maria presso San Satiro. But the moment he got to Rome he looked around at the huge scale of the Roman ruins, threw off all that Milanese demand for decoration and started thinking gigantic. St. Peter's is the result—although he never lived to see it completed, and when it was finished it no longer closely resembled his design.

1480~1516

Round and Round

Bramante

You can call Bramante, the great pioneering architect of the High Renaissance, many things—but you could never call his buildings modest. In fact, his plan for a gigantic circular version of St. Peter's in Rome was so over the top that some people say it actually brought about the Reformation. The soaring cost of building it meant that the Catholic Church had to seriously boost the sale of indulgences—documents that let you off penance for sins—to pay for it. Protestantism was the result.

The Tempietto temple in Rome (1502): Bramante's vision of what a church should be.

D onato BRAMANTE (*c.* 1444–1514) was growing up near Milan just after a change of political control in the city brought the mercenary-turned-prince *Francesco SFORZA* (1401–66) to power. With the support of the Medicis, the new regime lured artists from Florence, including Michelangelo and Leonardo, who propagated the values of the Renaissance and blew the dust off the old-fashioned people of Milan.

Bramante himself arrived from Urbino in 1477, and started out as a painter and draftsman. He was deeply influenced by Mantegna, with his ancient ruins and his classical ideals (*see page 31*). A generation later, Bramante

1512 The English Royal Navy introduces double-decked battleships weighing 1000 tons, each with 70 guns.

1514 Fresh green peas become fashionable in England but dried peas are more commonly used, especially in "pease porridge."

1515 Hampton Court Palace is completed near London for Cardinal Wolsey.

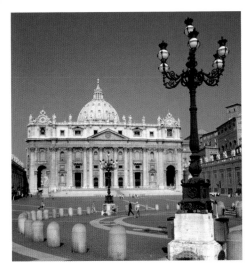

St. Peter's (1506): designed by Bramante, but changed by his successor architects (Michelangelo designed the dome).

There are two things we need to remember about Bramante, the great forerunner of Baroque architecture. First, his penchant for round buildings—check out his Tempietto in Rome (1502), marking the spot where St. Peter met his end. Even St. Peter's itself was intended to be round.

Second, he didn't like too much decoration—and was criticized for it by his followers, Raphael (*see page* 102) among them, the moment he was dead. His buildings looked classical, but also of the moment too. Bramante was responsible for translating ancient Roman architecture for a whole new world audience.

was in Rome—invited by the Borgia pope Alexander VI (*see page* 88), but was in even greater demand from his successor, the warlike patron of the arts, Julius II (*see page* 106). His crowning achievement was laying the foundation stone for his design of the new St. Peter's, on the site of the 1,100-year-old church of Constantine that Julius had just demolished. In the meantime, he presided over the destruction of so many Roman streets that he became known as "Ruinante."

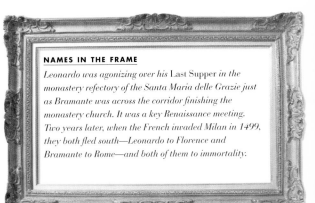

NAMES IN THE FRAME

Leonardo was agonizing over his Last Supper *in the monastery refectory of the Santa Maria delle Grazie just as Bramante was across the corridor finishing the monastery church. It was a key Renaissance meeting. Two years later, when the French invaded Milan in 1499, they both fled south—Leonardo to Florence and Bramante to Rome—and both of them to immortality.*

1492 Henry VII agrees to withdraw from Boulogne for a fee of £149,000.

1493 *The Nuremberg Chronicle*, an encyclopedia illustrated with woodcuts, fails to include any of Leonardo da Vinci's designs.

1500 Pedro Cabral, Portuguese explorer, accidently reaches the coast of Brazil on his way to the East Indies.

1485~1519

The Magnificent Man and his Flying Machines
Leonardo's scientific genius

It's time to look at the strange idea of "Renaissance Man." The reference books are full of them at this stage in history—from Alberti to Zabarella, each of them a multitalented genius in his own field. But it was Leonardo da Vinci who really deserves the accolade more than anybody. Not only did he revolutionize Western painting (although managing to finish remarkably few in his long career), he also seems to have invented tanks, flying machines, steam cannons, portable bridges, and musical instruments—and made himself the most subtle and knowledgeable anatomist of his day.

B ut as with his art, Leonardo rarely seemed to follow through on his astonishing scientific sketches or inventive ideas. There was no finished tank, nor flying machine that we can look back to, and say that he built it. It may be, of course, that his ideas needed the knowledge of the 20th century to bring them to fruition, but we cannot

ABOVE Sketch for a monument to Francesco Sforza (*c.* 1488): he seems to have studied equine anatomy as well.

LEFT Leonardo's sketches of a human embryo (*c.* 1489): he was probably the foremost physiologist of his age.

1503 The poem "The Thissill and the Rois" by Scottish poet William Dunbar is composed as a political allegory to honour Margaret Tudor, whose marriage to James IV he helped to negotiate.

1510 "Anatomy" by Leonardo da Vinci contains drawings from life based on corpses that Leonardo has dissected; he does not allow his work to be published.

1517 The galley *Virgin Mary* is launched with Henry VIII blowing a large whistle "almost as loud as a trumpet."

dismiss the possibility that it may have been his habit of staring at his creations, contemplating them for days at a time, that prevented them from developing any further.

Some of his notebooks, written in mirror-writing, weren't discovered until 1965. They show the results of his dissection of more than 30 bodies, and the sketches of military machines (1487) that he mentioned in his letter of application to Lodovico Sforza, the Duke of Milan (*see page* 92), listing his achievements as a military engineer. "Oh yes..." he seems to say as an after-thought. "I am also an architect, painter, and sculptor."

INVASION AND DISAPPOINTMENT

When the French invaded Milan in 1499, Leonardo went back to Florence to work as a military engineer for Cesare Borgia (*see page* 88). There, he busied himself with his wall paintings, and he also threw himself

Leonardo's commission as a senior military engineer by Cesare Borgia (c. 1502).

into the study of anatomy, and through dissection learnt everything he could about the workings of the human body. His unfinished statue of Sforza, meanwhile, was destroyed by French archers using it as target practice.

Yet despite all this, he seemed to have no interest in making his ideas public. He wrote most of them down in mirror-writing—he was left-handed—so nobody could read it and accuse him of being a heretic. Perhaps this was just as well: one of his observations was that "the sun does not move"—a belief for which Galileo would eventually be sent to prison.

> **Jack of all trades**
> Some mention should be made of Leonardo's other skills. He was fascinated by the science of physiognomy, interpreting the shape of people's faces. He was a master horseman, an expert in the dynamics of water, and a brilliant performer on the *lira da barccio*—an early form of violin.

TECHNO BOX

Leonardo's flying machines first made an appearance in his notebooks in 1488. By 1505 he was planning to "launch a flight of swans" from Monte Cerceri near Fiesole. A model made from Leonardo's designs in 1988 would have dropped like a stone—it was far too heavy to fly. In 2000, the 38-year-old British skydiver Adrian Nicholas successfully tested Leonardo's design for a parachute by jumping from a hot-air balloon above South Africa. "It took 500 years to find a man with a brain small enough to actually go and fly it," he claimed.

1503 England's Canterbury Cathedral is completed in Norman-Gothic style after 436 years of construction.

1520 A new wing is added to the Doge's Palace in Venice to replace a structure destroyed by fire in 1483.

1528 Austrian evangelist Jacob Hutter founds a "community of love" whose Austrian, German, and Swiss members share everything communally.

1490~1564

Divinely Terrible
Michelangelo

When someone is described as "divine" in their own lifetime, when they are talked about as the greatest artist in history (and at the same time as Leonardo and Raphael are knocking around) it makes it a bit difficult to do them justice in words alone. How do we deal with a phenomenon that seems to be approaching superhuman, and is recognized as probably the supreme artistic genius that has ever lived?

Difficult. But nevertheless, here is the life of *MICHELANGELO Buonarroti* (1475–1564), the pivotal point in the story of the Renaissance. Everything that comes before—the classicism, the grace, the psychological complexity—seems to culminate in his work. Everything that comes after responds to it. Michelangelo himself outlived the Renaissance. His last works reflect the darker world forming at the end of his life: take a look at his *Last Judgment* on the Sistine Chapel altar wall (1536–41) and you'll see what I mean.

Michelangelo—painter, architect, and poet—primarily wanted to be remembered as a sculptor. Indeed, it was his *Pietà* in St. Peter's in Rome (1499) that catapulted him to fame at the age of 24. He had moved there temporarily from Florence, where—unlike most

Michelangelo's *Pietà* (1499): critics were impressed but said the Virgin was too young.

Tribulations
Michelangelo conceived Julius' tomb as a massive project with more than 40 different figures, but Julius decided to pull down the cathedral instead and Michelangelo stormed off in high dudgeon (*see page 106*). He was awarded a second contract by the pope's family in 1513, after Julius had died, but the scale was much smaller. By the fifth contract in 1542, it was a mere shadow of its former glory. Michelangelo finished work on it three years later at the age of 70.

1531 In Mexico, the Virgin Mary appears to Juan Diego in a vision, instructing him to persuade the bishop to build a church to her on Tepeyacac Hill.

1533 The double boiler called by Italians the *bagno maria* after the legendary alchemist Maria de Cleofa is introduced to the French court by Catherine de' Medici.

1534 The first written description of a tomato appears in an Italian chronicle that calls the small yellow fruit *pomo d'oro* (golden apple).

NAMES IN THE FRAME

No other artist before Michelangelo managed to inspire two biographies in his own lifetime. The first was by the great historian of the Renaissance, **Vasari** *(see page 136), who described Michelangelo as the "archetype of genius" (1550). The second was by his pupil* **Ascanio Condivi** *(1553). Michelangelo did more than anyone else to create the idea that artists were potential superstars.*

Platonist followers of Lorenzo de' Medici, who believed in the existence of "perfect forms" somewhere in the universe, of which the earth is just a pale reflection.

Then there is the idea of what contemporaries call *terribilità*—the sheer emotional intensity of his figures. For an example, check out the violent contortions in *The Cross-Legged Captive* (1527–8).

artists—he had been born into minor nobility, and where he spent his early years studying Donatello, copying Giotto and Masaccio, and as apprentice to Ghirlandaio (*see page* 19).

He was famously difficult to get on with, but also ferociously loyal. He stuck at Pope Julius II's tomb—the "tragedy of the tomb" he called it—on and off for 40 years and his best work was probably done under the direction of the same guy. But although he spoke for his own time, there are some aspects of his art that are distinctively his own. Like his idea of the heroic male nude, his statue of *David* (*see page* 104), or his figures of God creating Adam on the Sistine Chapel (*see page* 110)—all representations of perfect human beauty. Michelangelo spent his youth with the neo-

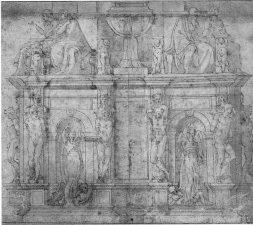

A copy of Michelangelo's second design for Julius' tomb (1513), redrawn by Aristotele de Sangallo after the original drawing was lost.

1513 Ponce de Leon discovers Florida on Easter Day and goes ashore to plant some oranges and lemons.

1514 "Not only the Christian religion but nature cries out against slavery and the slave trade," says the new pope Leo X, but the trade continues to grow.

1524 Chief Tecum Uman descends from his golden litter and kills the horse of Pedro de Alvarado, a lieutenant of Hernan Cortés, in the belief that man and horse are one. Alvarado runs the chief through with his sword, and panic spreads through the Quiche warriors.

1492~1540

Over There
The discovery of America

The discovery of America wasn't so much a sea voyage that risked a plunge over the edge of the world—although some of the crew of the Santa Maria probably thought so—but more a trip resulting from a breathtaking miscalculation about the circumference of the globe by Christopher COLUMBUS (1451–1506), the Genoese adventurer. Columbus got it all wrong. It was rather a habit of his.

Legal wrangles

Less than six months since land had been sighted from Columbus' ship, the *Pinta*, Pope Alexander VI (*see page 88*) intervened to hammer out an agreement between Spain and Portugal whereby the New World would be divided between them. They didn't like it, and the next pope, Julius II—taking time off from commissioning Michelangelo—had to help draw up the Treaty of Tortesillas in 1506, which gave Brazil to the Portuguese.

While Michelangelo was busily demonstrating the Renaissance idea of mankind as a race of noble giants with perfect thighs, Columbus was trying to act out the fantasy. None of this cramped medieval hopelessness—he would conquer the elements, bringing back untold wealth from the Indies, and crown himself, according to his contract with the Spanish Queen Isabella. "Grand Admiral of the Ocean Sea."

Of course it wasn't quite like that. In 1492 the Sephardim Jews were expelled from Spain. And while the sheer grandeur of the discovery of America fed into European culture, the aspect of humanity that Columbus revealed

Columbus arrives somewhere he didn't really expect: a new world.

1528 Cocoa beans are brought to Europe for the first time.

1529 The hymn "Away in a Manger" is written by Martin Luther.

1535 Anabaptists throughout Northern Europe are forced into hiding as a wave of repression sweeps Germany, Holland and Switzerland.

as he sighted the Bahamas on October 12, 1492, hungry for gold, wasn't noble at all.

The first thing the Europeans did was to separate the locals from their jewelry, and Columbus himself—investigated by Spanish officials for his behavior—ended up shackled and under arrest, bitterly trying to regain his land and property. And that was just one of a number of fine messes he got himself into.

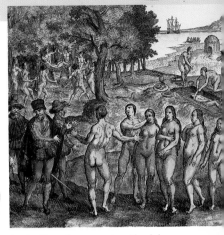

Amerigo Vespucci's "discovery" of the mouth of the Amazon in 1499: he got the whole American continent named after him.

NAMES IN THE FRAME

The name "America" was coined by the German map-maker **Martin Waldseemuller** *(c. 1470–c. 1522). He showed it as a separate continent in his 1507 map, quoting Amerigo Vespucci's letters and suggesting that the continent should be called after him. The map was lost until 1901, when a copy turned up in a castle in Württemberg.*

DIAS (c. 1450–1500) rounded the Cape of Good Hope to the Indian Ocean in 1488; the Florentine merchant *Amerigo* VESPUCCI (1454–1512) discovered the mouth of the Amazon in 1499; *Vasco da* GAMA (1469–1524) reached India by sea; and the notorious Spanish conquistador *Hernan* CORTÉS (1485–1547) began the brutal conquest of Mexico in 1519. In all their minds, gold was uppermost.

Garbled versions of Vespucci's letters were published in Florence in 1504. Soon the New World and the final expulsion of the Moors from Spain, also in 1492, were capturing the imagination of Europe. But the influx of gold also brought serious inflation—Spanish prices were four times higher at the end of the 16th century than they had been when Columbus set sail. The grandeur of mankind had a limit.

DRIVEN BY GREED

The truth was that, as he grew up, and the old medieval world view had begun to disappear, a modern hunger for money had swept through Europe—with the great Medici bankers at one end, and the adventurers and navigators at the other. So it was that the Portuguese *Bartolomeu*

1493 Cesare Borgia is made a cardinal by his father but he renounces his ecclesiastical career in 1498 for more lethal pursuits.

1498 In China, the first toothbrush is used.

1506 4000 Jews are killed in a riot in Lisbon.

1492~1519

Passion and Poison
The Borgias

That eventful year—1492—also saw the election of one of the most unpopular and feared popes in history—Rodrigo BORGIA (c. 1431–1503), known as Alexander VI. For the next 30 years, Italian politics and religion were dominated by the notorious Borgia family, as military leaders, dangerous political opponents, and wealthy patrons of the arts. It was a peculiarly Renaissance combination.

Titian's portrait of Alexander VI (*c.* 1506), aka Rodrigo Borgia, introducing the papal legate to St. Peter.

Most historians now say the Borgias had a bad press, mainly because they were foreign—from Aragon, in fact. But they have nonetheless gone down in history as a byword for cruelty and ruthlessness. Popes were well known for having illegitimate children, but Rodrigo excelled himself. He made his son *Cesare* (*c.* 1475–1507) an archbishop and then a cardinal the moment he was Pope, even though he was only 18. He fast became his father's closest advisor and—some

Suspicious deaths
Cesare Borgia probably had his brother assassinated, so that he could take over from him as captain-general of the Church. As such, he reconquered many of the small Italian states, and divided the great alliance that had been forged to frustrate his plans for a new kingdom of central Italy. He and his father, the Pope, fell disastrously ill at the same dinner—leading to his father's death and his own banishment. Was it poison?

Cesare Borgia: ruthless, brilliant, and dangerous to know. Don't accept dinner invitations.

1510 Pope Julius lifts his excommunication of Venice on February 10 and turns against France's Louis XII.

1516 Hispaniola's inspector of gold mines presents six loaves of sugar to Spain's Carlos I.

1519 Leonardo da Vinci dies. In his notebooks he had written, "While I thought that I was learning how to live, I have been learning how to die."

NAMES IN THE FRAME

Lucretia's last husband **Alfonso I d'Este** *(1476–1534) left the artistic side of being Duke of Ferrara to her while he played around with his real passion, guns. But his sisters* **Beatrice** *(1475–1497) and* **Isabella d'Este** *(1494–1539) were leading patrons of Leonardo, Raphael, and Titian. And his son* **Cardinal Ippolito II** *(1509–72) built the Villa d'Este, the most famous Renaissance garden in Italy, and was a patron of the composer Palestrina (see page 78).*

father, but she did become a major patron of the arts at Ferrara. She married three times, always for political reasons, and the first time at the age of 13. Her first husband had their marriage annulled, her second was murdered by his bodyguard on orders from Cesare, and the third—the Duke of Ferrara—witnessed Lucretia's death from an infection after childbirth.

would say—assassin. In 1498, Cesare started a second career as a warlord, conquering the Papal States and trying to carve himself out a hereditary kingdom—and in doing so, turning himself into the hero of Machiavelli's book, *The Prince (see page 116),* into the bargain. According to Machiavelli, Cesare's big mistake was being too ill to influence the election of his father's successor. The result: the arrival of his enemy Julius II *(see page 106),* banishment, and imprisonment in Spain and death on the battlefield. You can't say much in Cesare's favor, except that he certainly knew his stuff, and he did take the trouble to commission Leonardo.

Cesare's devoted sister *Lucretia* (1480–1519) probably didn't really have incestuous affairs with her brother and her

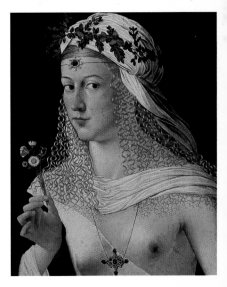

Lucretia Borgia by Bartolomeo (c. 1493) was to become a major patron of the arts, but she had pretty rotten luck with her husbands.

1514 Henry VIII makes a peace treaty with Scotland and France; France cedes Tournai to England but will later buy it back for 600,000 crowns.

1515 In Cologne, the satirical "Epistolae Obscurum Virorum" ("Letters from Obscure Men") supposedly by letter-writer Octvinie Gratuis mocks pleasure-seeking monks.

1537 The Inca Manco Capac II rebels against Pizarro and establishes a new state at Vicabamba.

1493~1580

Clowning Around
Renaissance theater

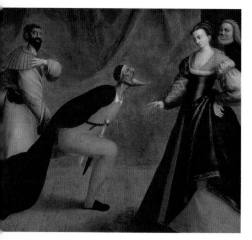

This 16th-century painting shows characters, like *zani*, that were introduced by *commedia dell'arte*.

While Mantegna was digging up Rome and the world of art and archaeology rapidly seemed to be merging into one, it probably wasn't surprising that somebody should unearth distant memories of ancient Greek and Roman theater in all its guises. The Renaissance wasn't all "high" culture after all: there had to be somewhere to have a good laugh and enjoy the plays soon to be issuing from the pens of Bruno (see page 133), Machiavelli (see page 116) and Aretino (see page 118).

There were three main triggers for the theatrical Renaissance. First was the publication in 1493 of some of the stage designs that accompanied the translations of the plays of Terence, an ancient Greek comedy writer. Soon the architects were producing theaters to fit the bill, such as the Teatro Farnese at Parma (1618–19) or the Teatro Olimpico in Vicenza (1580–4) by the great architect Palladio (*see page 134*), which he modeled on the façade of a Roman theater.

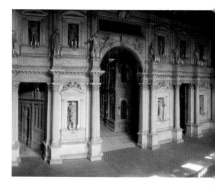

1550 Billiards is played for the first time in Italy.

1568 John of the Cross founds the first monastery of the barefoot Carmelites. Teresa de Avila establishes the order of the barefoot Carmelite nuns.

1580 New building is prohibited in London to prevent the city growing any larger.

NAMES IN THE FRAME

One of the most successful Italian playwrights of the day was **Machiavelli** *(see page 116), but other Renaissance playwrights, writing comedies about everyday affairs, managed to be pretty shocking, too. The ill-fated* **Bruno** *(see page 133), however—burned at the stake for heresy in 1600—didn't manage to get a first performance of his play, Il Candelaio, until 1905, when he wasn't around to read the reviews.*

The first scenic artist to publish his designs, Bolognese architect *Sebastiano SERLIO* (1475–1554), did so in 1545, and the Renaissance composer *Claudio MONTEVERDI* (1567–1643) was soon putting music and plays together to produce opera.

The second factor was the decline of the medieval religious plays. With the rise of the Reformation, they began to look a bit like propaganda. They were even banned in Paris in 1548 and in England in 1588, with the threat of the Spanish Armada. The future lay with the humanists.

And third was the mysterious rise of the *commedia dell'arte*, which combined clowning, singing, acrobatics, dance, and much else besides—performed by traveling actors who each specialized in a historic part for their entire lives. By the 1540s, the troupes were laying the foundations of modern theater, introducing familiar elements such as the comic servants, whose names included Arlecchino (later Harlequin), Pulcinella (later Punch), and Scaramuccia. Soon they had wandered as far as Moscow and London (1547). They were the first professional actors.

Palladio's version of what a theater should look like: the Teatro Olimpico in Vicenza (c. 1579–80).

Meanwhile, in England

The next stage in our dramatic history took place in England, where the first permanent theater was built in London by the actor and joiner James Burbage in 1576. The greatest Renaissance playwright of all emerged in faraway Stratford-on-Avon. In his plays, William Shakespeare (1564–1616) composed some of the classic definitions of Renaissance thinking on the dignity and glory of mankind. And with characters with names such as Petruchio and Romeo, his debt to the Italian Renaissance was pretty obvious.

1494 Poynings' Law states that no Irish Parliament shall be held and no legislation made without the consent of the English Parliament.

1502 Fernando de Roja's racy tales of Calista and Melibea (*La Celestina*) are published.

1506 An English worker can earn enough to buy 8 bushels of wheat by working for 20 days, 8 bushels of rye by working for 12 days, and 8 bushels of barley by working for 9 days.

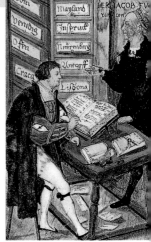

1494~1520

Funny Money
Pacioli and the new accountants

We are approaching the so-called "High Renaissance"—the time of Michelangelo, Leonardo, and Raphael. So how has an accountant crept in here? The answer is that the Venetian friar Luca PACIOLI (c. 1445–1517) was knitted into the Renaissance more than most, just at the point when numbers and perspective were at their most important. He was a pupil of Piero della Francesca (see page 60), a great friend of Alberti (see page 50), and after meeting him in Milan, a close pal of Leonardo's, too.

Bookkeeper turned artist: Matthaus Schwartz (left) painted this picture of himself (1516) working for Jacob Fugger

Then, just as Columbus caught his first glimpse of the New World, he sat down and began the book that made him famous, *Summa de arithmetica, geometria, proportioni et proportinalita* (1494)—cramming everything in there from astrology and military tactics to music ("nothing else but proportion and proportionality"). But it was the section on book-keeping that stayed in print for 500 years, still being translated into German and Russian well into the 19th century.

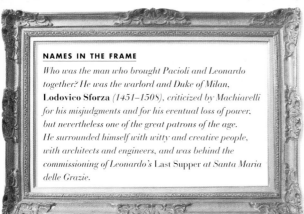

NAMES IN THE FRAME

Who was the man who brought Pacioli and Leonardo together? He was the warlord and Duke of Milan, **Lodovico Sforza** *(1451–1508), criticized by Machiavelli for his misjudgments and for his eventual loss of power, but nevertheless one of the great patrons of the age. He surrounded himself with witty and creative people, with architects and engineers, and was behind the commissioning of Leonardo's* Last Supper *at Santa Maria delle Grazie.*

1515 Havana, Cuba, is founded by Spanish conquistadors.

1519 The dollar has its origins in the "thaler," minted in Bohemia at Joachimsthal, where the large coin is originally called the "Joachimsthaler."

1520 England's Henry VIII and France's François I meet with 10,000 courtiers outside Calais on the Field of the Cloth of Gold. The celebrations last for three weeks and leave the French treasury depleted for ten years.

TECHNO BOX

Just because Pacioli developed a method of reducing everything to numbers, it didn't mean he was any kind of atheist. Far from it. He suggested starting each page of the ledger with the cross and with the name of God, a precaution other merchants had been taking for centuries (see page 25). He was the most famous mathematician of his generation—and even managed special dispensation from the Pope, despite his vow of poverty, to own property.

Pacioli didn't invent double-entry book-keeping—the method of keeping stock for merchants while their complicated deals were still on the high seas—but he set it down in a way that could be copied around the world. It was a way of making the world stand still for a moment and be counted, to quantify what sometimes seemed uncountable, and turn it all into simple profit and loss. It was known as the "Venetian style." Men of the church being interested in money? Whatever next? Funnily enough, the Pope gave his wholehearted approval.

When Pacioli went to Milan in 1497 and met Leonardo, he began preparations for his second book, *Divine Proportion* (1509), about mathematics and art—with illustrations by Leonardo himself.

Who said monks have to be poor?

Pacioli's work may not have been the Sistine Chapel ceiling, but it was enormously influential, and remains one of the most powerful of all Renaissance legacies. Things could be counted: there was no mystical or spiritual significance—they could just be reduced to numbers. The modern world had arrived.

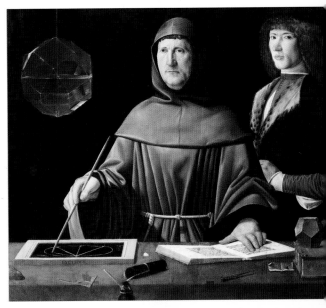

Jacopo de Barbari's painting of the first accountant, Fra Luca Pacioli (1490s), getting to grips with geometry.

1497 The Cabots reach Nova Scotia and return with reports that lead to the development of Newfoundland fisheries.

1499 Erasmus visits London and is impressed with English girls: "They kiss you when you arrive. They kiss you when they go away and they kiss you when they return. Go where you will, it is all kisses."

1511 A Spanish ship bound from Darien in Panama to Santo Domingo strikes a reef and founders in the Caribbean. Survivors reach the Yucatán, where some are killed and eaten and the remainder enslaved.

1495~1521

Scratching the Plate
Dürer

It was more than just artistic ambition with the German painter, printmaker, and publisher Albrecht DÜRER (1471–1528). From the moment he got a whiff of the Italian Renaissance, on a visit to Venice to see a student friend in 1494–5, he was determined to bring the revolution back home. If it meant hobnobbing with the princes of Europe, sitting at the feet of Bellini, learning languages, and personally revolutionizing an artist's status, then Dürer would do it.

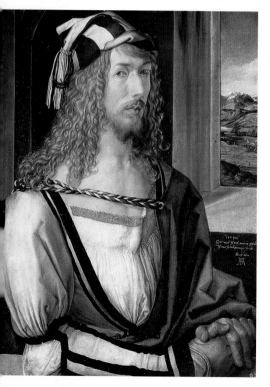

Dürer's self-portrait, (1500) age 29: did he deliberately try to make himself look like Christ?

A nd he did. And all as a result of a trip to visit his humanist friend Wilibald Pirckheimer in Padua. Soon he was studying classical literature, math, and geometry, and—back home in Nuremberg—made sure he shunned the artisans that artists were supposed to hang around with for the company of scholars. For Dürer, the key to art was geometry: there must be some rational system of proportion that governed the way the human

1516 Thomas More's *Utopia* tells of a group of pagans living on a remote island.

1518 Thomas Wolsey, son of a butcher, is appointed Henry VIII's papal legate, which irritates the nobility.

1521 In Zurich Huldreich Zwingli condemns the hiring of mercenaries.

body should be portrayed—he was sure the Italians had discovered it (see his *Adam and Eve* of 1507).

His paintings have all the classical grandeur of the Renaissance—see him in his masterful self-portrait (1500), looking young, confident and every inch the modern hippy setting out on an artistic quest. It was his engravings, however, that changed the way art was executed. There had rarely been such a skillful draftsman as Dürer, with his peculiar and sometimes monstrous creations, such as *Knight, Death, and the Devil* (1513). His terrifying pictures of apocalyptic events (1498) were copied all over Europe at the dawn of the Reformation (*see page* 122)— and fed the idea that something tremendous was about to happen.

NAMES IN THE FRAME

Dürer was so famous that he almost eclipsed his great German rival, Grunewald. Grunewald's real name, as far as anyone knows, was **Mathis Neithardt-Gothardt** *(c. 1470/80–1528), and almost nothing is known of his life. His* Crucifixion *on the Isenheim Altar (1515), however, is famed for its frightening intensity.*

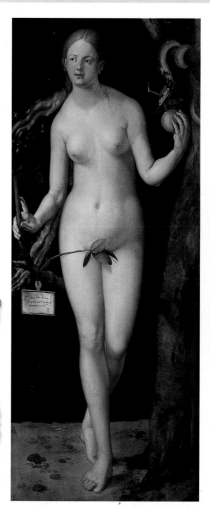

Dürer's *Eve* (1507): he believed there was a rational system of proportion to the human body and was determined to crack the code, but he is remembered more for his graphic innovations.

1500 "Adages" ("Adagia"), a collection of sayings from classical authors, by Dutch humanist Desiderius Erasmus is published in Paris.

1517 Seville Cathedral is completed after 115 years of construction.

1520 Raphael dies in Rome age 36, leaving his *Transfiguration* incomplete.

1500~1550

We Can Do It!

The High Renaissance

If you concentrate on the dignity of man for long enough, you can come to believe you're invincible. It was like that for all those Renaissance types. Only a century before, they had been dragging themselves out of the gloomy Middle Ages. But suddenly, as the 16th century dawned, there was nothing they couldn't do, nothing that couldn't be made into art. Artists were covering the ceilings with demigods and felt a little like demigods themselves. It was a high point in human optimism, and the start of a period known as the High Renaissance.

The status of art

By the time of the High Renaissance, artists had made it to the very top. When a pope could plead with Michelangelo to return to Rome to paint his ceiling, and when the Holy Roman Emperor Charles V could stop to pick up one of the paint brushes dropped by Titian, it's obvious these men are not just ordinary tradespeople any more, and that they've finally made it to the top of the ladder.

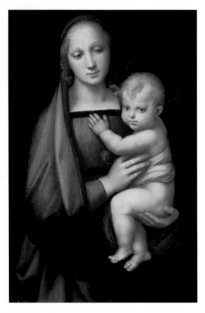

The other side of the High Renaissance: one of Raphael's many Madonnas, this one is the *Grand Duke's* (c. 1504).

The High Renaissance is best known as the period of the four giants: Leonardo, Michelangelo, Raphael, and Titian; but to the popularizer of the Renaissance, Giorgio Vasari (*see page* 136) —who knew all of them—it was all about grace, or *grazia*. Grace, to him, meant a mixture of harmony, beauty, and that appearance of ease that the masters of Renaissance painting and sculpture were managing to achieve.

It was about a lot of other things, too. This was a time when the demigods tried to inch above each other using the scope of their imagination and by the boldness of what they were trying to do.

1524 German mathematician Peter Bennewitz proposes a lunar observatory to produce a standard time that may help navigators determine longitude.

1527 Conquistadors return to Spain reporting that the natives of New Spain eat algae, agave worms, winged ants, tadpoles, water flies, white worms, and iguana.

1543 Copernicus revives the heliocentric ideas of Aristarchus in "De Revolutionibus Orbium Coelestium" ("About the Revolutions of the Heavenly Spheres") published the year he dies.

Titian's *Bacchus and Ariadne* (1523) sums it up: sumptuous, colorful, and not quite real.

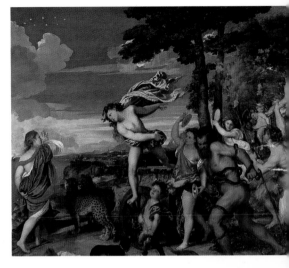

SKY'S THE LIMIT

It was a time when sheer size was important. Why not cover the whole of the Sistine Chapel ceiling? If you're going to produce another statue of David, why not make this one 85 feet high? If you're going to portray the glory of mankind, then you should do it with great muscular naked giants.

It was also the first great era of oil paintings. Colors could be blended, made "smoky," or used to achieve brand-new and extraordinary effects, whether the colors used were realistic or bright and unnatural-looking.

And it was also a time when the ambitions of artists escaped their confines and ran amok among the princes and popes who could afford them. It wasn't enough for Pope Julius II to order a few new paintings—he had to have the venerable St. Peter's demolished to make way for a new cathedral, the like of which had never been seen before. That was the trouble with the Renaissance: too much hubris.

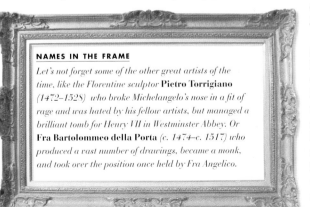

NAMES IN THE FRAME

Let's not forget some of the other great artists of the time, like the Florentine sculptor **Pietro Torrigiano** *(1472–1528) who broke Michelangelo's nose in a fit of rage and was hated by his fellow artists, but managed a brilliant tomb for Henry VII in Westminster Abbey. Or* **Fra Bartolommeo della Porta** *(c. 1474–c. 1517) who produced a vast number of drawings, became a monk, and took over the position once held by Fra Angelico.*

1500 Writings are discovered by 10th-century Saxon canoness Hroswitha of Gandersheim, including six Latin plays, making her the first known German playwright.

1501 Ascension Island is discovered.

1504 Coins are minted bearing a likeness of Henry VII.

1500~1510
A Certain Smile
Mona Lisa

It's time to look at one of the most famous paintings in the world, and one of the best examples of a Renaissance portrait—still inspiring and mystifying as it hangs in the Louvre in Paris, almost 500 years after it was painted by Leonardo da Vinci.

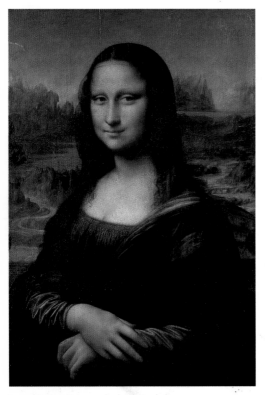

Leonardo's *Mona Lisa* (1503–6): notice that the landscapes don't match on either side of her head. Nor do the two sides of her mouth. Vasari wrote that it seemed like "living flesh."

It's true that the Mona Lisa's mysterious smile is one of the most over-reproduced images in history—probably the most copied face before Marilyn Monroe and Princess Diana. But don't let that put you off. Leonardo was so pleased with it that he took it with him everywhere—which partly accounts for the fact that this is one of the few of his portraits to have survived.

We don't know her name, although the portrait is also known as *La Gioconda*, supposedly after her husband —a Florentine official—and we certainly don't know what she's thinking. Sometimes she seems to be pretty friendly; sometimes she's freezing us out. Sometimes she's mocking; sometimes she's sad. She's a bit of all of them. But we do know a bit

1506 The Bakócz Chapel of Esztergom Cathedral, Hungary, is begun. It will be one of the earliest and purest examples of Renaissance architecture outside Italy.

1508 Archbishop Warham of Canterbury and Abbot Bere of Glastonbury argue over which of them has the genuine bones of St. Dunstan.

1509 Henry VIII comes to the throne at the age of eighteen and marries Catherine of Aragon.

TECHNO BOX

Three years to paint a portrait! That was nothing for Leonardo. Those who watched him painting his *Last Supper* (1495–7) used to say that he would spend whole days at a stretch standing with folded arms looking at his work before he could bear to paint another stroke—and then he would disappear off again for the day. His love life was always a bit of a mystery, and some speculate that maybe he loved the woman in the *Mona Lisa* painting himself.

If you look at his famous "cartoon" of the *Madonna and Child with St. Anne* in the National Gallery in London, both women look remarkably like the Mona Lisa. The strange smile is there too. So the wife of a Florentine official bears the face of Leonardo's muse.

Perhaps it isn't surprising that Leonardo and so many millions after him seem to have spent so much time just staring at it.

Leonardo's study of St. Anne (1501) for one of his famous cartoons: there's something familiar about that smile . . .

. . . and his study for the Virgin (1501) in the same picture displays another enigmatic mouth.

about how Leonardo achieved this peculiar effect: the two sides of the picture don't quite match, and nor do the two sides of her face.

He painted her between 1503 and 1506 during the second stage of his career in Florence, once he had already established himself as the greatest anatomist of his day. As an artist, he really knew how to make people seem alive in a way that no painter had ever done before. He did this not only through his "smoky" oil painting technique, through which part of her expression merges into the shadows, but also through his rendering of the psychological depth of human beings. He may rarely have finished a project, but that was probably because he was so focused on the detail there was never a moment he could bear to call it a day.

Inner life

If you want to see a revolution in psychological subtlety, check out Leonardo's *Last Supper* (see page 27), painted as if it was at the moment that Christ revealed that somebody there would betray him. Every face is a portrait of emotional complexity.

1500 In Switzerland, Frau Nufer performs a "Caesar" operation fearing for the health of his wife and child during a difficult labor.

1517 English sailors complain to King Henry VIII about the growing numbers of French cod fishermen in Newfoundland.

1527 English trade with Russia begins.

1500~1536
Drop Me a Line
Erasmus, More, and the humanists

Keeping pupils interested, rather than beating education into them, sounds like a pretty modern attitude to schooling. So does putting the importance of learning and the intellect over superstition and religious corruption. But it was also the very stuff of Renaissance "humanism," and the brilliant scholar who interpreted all those funny new Italian ideas for northern Europe—and took it much further—became a byword for the whole intellectual potpourri. He was Desiderius ERASMUS (c. 1466–1536).

Erasmus of Rotterdam, deeply engrossed in his favorite occupation.

The missing surname

Erasmus was born in Rotterdam—nobody quite knows when—out of wedlock, which meant he had no surname. Erasmus was just his father's name Gerhard in a mixture of Latin and Greek. It means "beloved."

For nearly 40 years, he wandered around Europe as a tutor and lecturer, looking for old manuscripts and writing letters—there are 1,500 of them still in existence. By the end of his life he was getting replies and presents from kings and princes all over Europe. Not to mention popes.

Erasmus may have got on well with the rulers of his time on a personal level, but he had little regard for the way they all behaved. After his visit to Italy he dashed back to England to write *Praise of Folly*—one of the first ever bestsellers. It was a diatribe against the behavior of princes, shot with biting sarcasm, and it went through seven editions in a few months.

The household of Erasmus' great friend, Sir Thomas More, by Rowland Lockey (c. 1593).

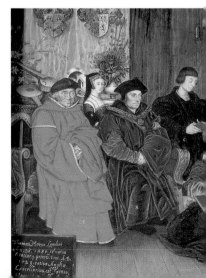

1530 Georgius Agricola begins work on his treatise on metallurgy "De re metallica" (published 1556).

1532 Rabelais publishes *Pantagruel*, a satire of a popular folk tale, and it is an instant success.

1533 Algerian corsair Khair ad-Din evacuates the Moors driven from Spain by the Inquisition.

A MAN OF LETTERS

Like all the great humanists of the day, Erasmus spent most of his time translating the great works of the classical authors. When he wasn't writing letters, he was scribbling away by the light of a candle in the great libraries of Europe, in his battle with the Church over corruption, ignorance, and superstition.

Humanism didn't mean quite what it does now: Erasmus and his friends weren't atheists—in fact he was ordained a priest and given special permission by the pope to live as a scholar instead. Nor were they part of the Reformation, although they paved the way for it. Erasmus was accused of being a follower of Luther (*see page 122*)—but he actually spent most of the 1520s engaging with him in a furious exchange of angry pamphlets. For people

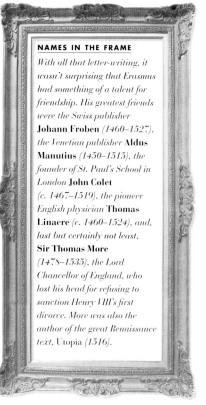

NAMES IN THE FRAME

With all that letter-writing, it wasn't surprising that Erasmus had something of a talent for friendship. His greatest friends were the Swiss publisher **Johann Froben** *(1460–1527), the Venetian publisher* **Aldus Manutius** *(1450–1515), the founder of St. Paul's School in London* **John Colet** *(c. 1467–1519), the pioneer English physician* **Thomas Linacre** *(c. 1460–1524), and, last but certainly not least,* **Sir Thomas More** *(1478–1535), the Lord Chancellor of England, who lost his head for refusing to sanction Henry VIII's first divorce. More was also the author of the great Renaissance text,* Utopia *(1516).*

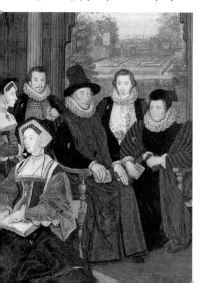

like him and his friend Sir Thomas More, Protestant ideas threatened to bring down the foundations of civilization.

What the humanists did want to do was to shed light in the dark medieval corners that remained, and to do so with tolerance and wit. In this respect, his aims, attitudes, missives, and teachings made him the first citizen of the modern world.

1500 A Garden of Contemplation is laid out in the grounds of the Buddhist temple of Ryoan-ji in Kyoto, Japan.

1503 In Panama, Columbus notices natives playing with black bouncing balls made of rubber.

1505 There is a regular mail service between Vienna and Brussels.

1500~1520

The Charmer
Raphael

It was one of the great conspiracy theories of the Renaissance. Did Bramante and the young Raphael break into the Sistine Chapel, still full of scaffolding, and take a peep at Michelangelo's closely guarded secret ceiling? Or did Raphael share the first glimpse of it—a crucial moment in the High Renaissance—with everyone else, on August 14, 1511? The question is important because the ceiling influenced Raphael enormously. In his School of Athens (1509-11), you can see a figure in the front looking remarkably like one of Michelangelo's Sistine prophets and sibyls—and it wasn't in the original cartoon sketch.

Madonnas

If Raphael had died even earlier, he would have been known primarily for a string of beautiful, graceful and human Madonnas that he painted in Florence (see the *Madonna del Granduca* of 1505), borrowing a little bit of Leonardo's *sfumato*. A generation later, as the Counter-Reformation was taking charge, Madonnas started to appear more as super-humans, sitting on clouds. Raphael was the pivotal figure in this shift.

In fact, it looks remarkably like Michelangelo himself—grumpy and wearing boots. Either way, Michelangelo accused Raphael of stealing his ideas, and the two great figures of the High Renaissance tripped over each other with distaste all across Rome. But while

Is this Raphael's portrait of Michelangelo (1509–11), crouched in the foreground of *The School of Athens*? Michelangelo wasn't pleased.

Michelangelo was a notoriously difficult loner. Raphael was sophisticated and charming and well able to organize for himself a powerful workshop full of assistants. Together they simply churned out the stuff until his unexpected death on Good Friday 1520.

Raffaello Sanzio (1483–1520)—his real name—was deeply influenced by Leonardo: compare their complex portrait styles and sense of graceful movement. While Michelangelo was grand and ponderous, Raphael's figures had grace, and were fairly leaping around the canvas. His intimate approach to portraiture—see

1509 Erasmus writes *In Praise of Folly*, a witty satire on lay and ecclesiastical society.

1517 Coffee is introduced to Europe.

1520 Ferdinand Magellan negotiates a difficult 38-day passage through the straits at the southernmost tip of South America; he sails into the South Sea, and renames it the Pacific Ocean.

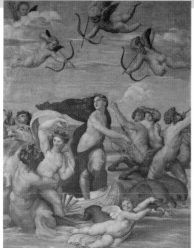

Typical Raphael: his *Triumph of Galatea* (1513), a fresco in the Villa Farnesina, is a perfect example of his line in tortured flesh.

that, he arrived in Rome in 1508 just as Julius II was revamping the place (*see page 62*). He became the central figure in the city's artistic revival.

He was soon overwhelmed with offers of work from aristocrats all over Italy and, when Bramante died, he took over as chief architect for St. Peter's and became Superintendent of Antiquities—amid the growing fears that the Pope's architectural ambitions would destroy what remained of ancient Rome.

When he died of plague on his 37th birthday—there's an apocryphal tale that he died from too much sex—a rumour was circulating that he would have soon been made a cardinal. Probably neither story was true. At any rate, the idea that artists couldn't be gentlemen was gone for ever. Most important of all, Raphael began to back away from Renaissance realism: he wanted *ideal* beauty.

the one of Julius II—was part of the revolution in individualism. He also shifted away from the focus on male bodies of the previous century, and started painting hoards of attractive, sensual women instead.

He was the son of an artist and an infant prodigy, but in Florence he had felt inferior to both Leonardo and Michelangleo, and set about learning what he could from them. Armed with

NAMES IN THE FRAME

What Raphael's figures had that Michelangelo's lacked was grace—but where did it come from? The answer— from his great teacher Pietro Perugino (see page 61), probably himself a pupil of Piero della Francesca. Check out Perugino's Christ's Charge to St. Peter (1481), a fresco in the Sistine Chapel. The figures are graceful all right, but they do lack a certain fluidity; Raphael managed to combine the best of both—grace and movement.

1501 The firs hymnbook is published in Bohemia.

1501 Vasco da Gama wins control of the spice trade for Lisbon: he sets out with a fleet of 20 caravels to close the Red Sea, and cuts off the trade route through Egypt to Alexandria, where Venetian merchants had been buying spices.

1501 Amerigo Vespucci sails to Brazil and continues south to Rio del Plata, becoming convinced that he has found a new continent.

1501~1504

What Big Hands You Have!

Michelangelo's David

These days, if the richest city in the world put at its heart an 11-foot statue of a naked youth—especially one with a confused expression—you might wonder exactly what was meant. In early 16th-century Florence, however, the message was clear, even though nobody had created anything of the kind before. It declared that the city was central to a civilization, with ancient classical roots and with the dignity of mankind as its cornerstone. So the statue was erected outside the Palazzo Vecchio as a symbol of Florence's power.

Critical acclaim

David had "stolen the thunder of all statues," wrote Michelangelo's biographer Vasari (*see page 136*) just half a century later. And his opinion seems to have endured: for Kenneth Clark, in the 20th century, it was proof that Michelangelo was "one of the great events in the history of western man."

Research shows that *David* (1501–4) is slightly cross-eyed, but it gives the impression of a strong gaze.

The people of Florence identified with David in his fight with Goliath, and there were already coachloads of Davids cluttering the place up. The new statue, however, was going to be a sign of political defiance for the new republic, after the Medici rulers had been sent packing. (All Florentine citizens, even the Medicis, saw themselves as freedom fighters against tyranny.) Ironically, almost 40 years before, another sculptor had chosen the same massive bit of marble, botched it, and abandoned it. Michelangelo rediscovered it and turned it into a symbol for the city.

1502 Montezuma II comes to the Aztec throne at the age of 27.

1503 Christopher Columbus is marooned for a year in Jamaica after his vessels get shipworm.

1503 The first gol sovereigns are struc each worth 22 shillings and sixpence.

David (1501–4) outside the Palacio de la Signoria, originally Florence's Parliament: a symbol of democracy.

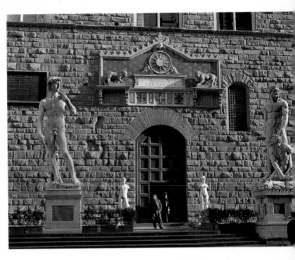

MORE THAN JUST A ROMAN GOD

He was only 26 when he started work on it, but by that time he had already been to Rome back in 1496, and had been completely overwhelmed by what he saw. He even sold one of his imitation Roman sculptures as a genuine antique. (Yes, Michelangelo started off with forgeries!)

David, when he was finished, was the biggest statue since classical times, but he was so much more than classical. The hands were famously just a little too big: perhaps that was about action. But the head is something the classical sculptors never managed. It has a heroic and spiritual quality about it that has amazed people ever since. Critics have compared the statue to Donatello's *David* (see page 36), and found in it nothing of the tragedy of human life that seems to emanate from the latter. Michelangelo's wasn't a vulnerable David. So maybe the furrowed brow isn't confusion after all—it's determination.

NAMES IN THE FRAME

Why this obsession with nudes? Michelangelo seems to have been following the lead from **Pollaiuolo** *(see page 71)—who was much given to engravings with titles like* Battle of Nude Men, *and who also influenced Leonardo. Then there was the Umbrian artist* **Luca Signorelli** *(1441/50–1523), whose Orvieto cathedral frescos (1499) are packed with human figures with very well-developed muscles.*

1505 Portuguese Francesco de Almeida is the first European to reach Ceylon.

1507 The sweating sickness that struck London in 1485 strikes once again.

1509 "The Ship of Fools" by English poet Alexander Barclay is published; he has adapted the popular German satire "Das Narrenschiff" of 1494 by Sebastian Brant.

1503~1513

Priest in Armor
Pope Julius II

He collected eight bishoprics and one archbishopric. He was a well-known military organizer, and he managed to get himself elected pope with the help of a little light bribery. He pulled down the 1000-year-old Basilica of St. Peter in Rome. He embodied everything that was corrupt about the late medieval papacy. Yet Julius II was also a financial genius and one of the creators of the High Renaissance.

NAMES IN THE FRAME

Julius was succeeded by **Giovanni de' Medici** *(1475–1521) as Leo X, who combined continued artistic patronage with an outrageous burst of hunting and feasting. But by now the scene was set for the Renaissance to come to a shuddering halt with the Sack of Rome. Starting on May 6, 1527, Imperial troops under the Duke of Bourbon devastated and gutted Rome, sending its artists and architects fleeing to other cities around Italy.*

Giuliano della ROVERE (1443–1513) became a cardinal at the relatively young age of 28. He was soon busy reconciling France and Austria, defending Rome from the armies of Naples, and getting on the wrong side of the Borgias.

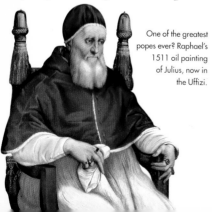

One of the greatest popes ever? Raphael's 1511 oil painting of Julius, now in the Uffizi.

When the Borgia pope Alexander VI (*see page* 88) was elected he had to escape briefly to France. But it was his importance to the Renaissance that concerns us here.

Julius was a great reformer, issuing a proclamation to prevent anybody else bribing their way to becoming pope after him. He gathered the greatest artists of the day around him in Rome, which meant bringing in Bramante to design the new St. Peter's and Raphael to paint his apartments. But today he's best remembered for his relationship with the unpredictable Michelangelo.

1509 The last of the Paston letters is written; this correspondence by a middle-class Norfolk family began in 1422 and is one of the main ways we know about life in the 15th century.

1510 The silk industry is established in Spain and Italy.

1513 The Scottish navy is sold to France.

SQUABBLES OVER A TOMB

Michelangelo spent six months in the Carrara quarries choosing the right blocks of marble for Julius's gigantic tomb in St. Peter's. It was going to be his greatest ever sculpture. But by then the Pope had changed his mind: he was going to demolish St. Peter's instead. Michelangelo was furious, and suspected that Bramante had poisoned his mind. He stormed off to Florence and wrote a rude letter to the Pope. Instead of pulling rank, Julius got Florence to persuade him to return, and cajoled the sulking and complaining Michelangelo to oversee the ceiling of the Sistine Chapel. The much-compromised tomb was finished after Julius' death.

Final judgement

Was Julius a goodie or a baddie? A bit of both. His ruinously expensive plans for St. Peter's meant the sale of indulgences had to be increased to such outrageous levels that they helped to provoke Martin Luther and the Reformation. On the other hand, he was the first pope to try to outlaw bribery, corruption, and nepotism within the Papacy.

Julius only reigned for a decade, but Italy was never the same again. Had he looked down from Heaven, he would have seen the continuing battles over his St. Peter's, and the Reformation looming in the distance. But did he get to Heaven? From wherever he was, he might also have caught a glimpse of Erasmus' satirical portrayal of the scene at the pearly gates, as Julius argues with St. Peter pompously and unsuccessfully that he should be let in.

Michelangelo showing the Pope what's what at Bologna in 1506: this reconstruction was painted a century later.

1505 The Merchant Adventurers Company holds a monopoly on the export of English cloth to Germany and the Low Countries.

1507 Albrecht Dürer paints Germany's first full-size nudes.

1508 The first book to be published in Scotland is a volume of Chaucer.

1505~1510

Gorgeous George
Giorgione

Popes, dukes, and doges, on the whole, liked their massive palace walls to be covered by pictures of momentous events. You know the kind of thing—demigods slaying snakes, victorious battle scenes, naked Old Testament prophets. Anything with enough glory to rub off on themselves. But now there was a new class of private collector beginning to emerge, whose tastes weren't quite so pompous. These people didn't have such big walls to fill, and they may not have known about art—but they certainly knew what they liked.

So it was that, starting in Venice, artists found themselves obliged to churn out smaller pictures, often of landscapes. After a century of trying to copy the great classics, they had only just got round to remembering that the great Greek writers were usually in raptures about the joys of the countryside (*see page 56*).

One of the artists to spearhead this trend was *Giorgio*

Patenier
About a thousand miles away in the Netherlands, other artists were also emerging who specialized in small mysterious landscapes. Check out Joachim Patenier (d. c. 1524), especially his *St. Jerome in a Rocky Landscape* (1515) with the world stretching into the far distance, just 20 years after Columbus discovered that there was a new world beyond the horizon.

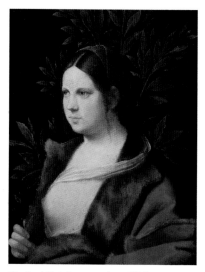

Giorgione's *Portrait of a Young Woman* (1506)—also known as Laura. This is one of his only five surviving paintings.

da CASTELFRANCO, known as Giorgione (Great George) (*c.* 1476/8–1510), a pupil of Bellini's, a follower of Leonardo's, and the first Venetian to start experimenting with small oil paintings. There's a problem, however: the artist who was supposed to have founded modern painting died of the

1508 Giorgione works on a group portrait of the Council of Ten in Venice (now lost).

1510 The word "architecture" comes into use.

1510 Henry VIII executes his chief tax gatherers Richard Empson and Edmund Dudley to try and make himself more popular.

NAMES IN THE FRAME

In his youth, Giorgione seems to have linked up with a host of other young colleagues, many of whom seemed to have helped by finishing his paintings after he died. Of these, Titian (see page 118) is best known; together they took Giorgione's techniques out into the world. Among them were **Vincenzo Catena** *(c. 1480–1531) and* **Sebastiano del Piombo** *(c. 1485–1547), who went to Rome and sided with Michelangelo in his battles with Raphael.*

plague after only a few years of activity, and only five pictures still in existence are definitely by him. Many of his others were certainly finished by people like Titian, who worked for him in 1508 painting frescos on the outside walls of the Fondaco dei Tedeschi.

There's another problem about Giorgione. Nobody now or at the time could understand what on earth he was trying to convey in his most famous painting *Tempesta* (*c.* 1505)—one of the first major Italian paintings to be described as a landscape. There was a naked woman breast-feeding, an apparently unconnected shepherd, a flash of lightning over the city in the background, and a twilight atmosphere before a storm. It was

the forerunner of paintings that would fill gallery after gallery with pastoral or erotic mood landscapes that would later become very fashionable. It was also part of the emerging trend to try to convey your subjects' emotions through the weather or environment.

Why all the landscapes, suddenly? Well, at the Battle of Agnadello in 1509, Venice lost most of her land empire. Some historians believe the landscapes are a nostalgic response to the loss.

Giorgione's *Tempesta* (c. 1505): why is she breastfeeding in the middle of a storm and what's the shepherd got to do with it?

1510 Japanese pirates known as "wako" ravage China's southern coast. Ships are often officered by Japanese sailors but crewed by Chinese, who cut off their pigtails and pretend to be Japanese.

1510 The xylophone appears.

1510 In London, the first commissioners of sewers are appointed to try and deal with the smell.

1508~1512

When Will You Make An End?
The Sistine Chapel ceiling

Imagine lying on your back, getting paint and plaster in your face every day for four years. It's not quite the heroic picture of an artist we have come to expect from Renaissance superstars like Michelangelo, so perhaps it isn't surprising he fought against having to paint the ceiling of the Sistine Chapel for so long. By the end, he got so used to it that, just to read letters, he would have to tip his head back and look

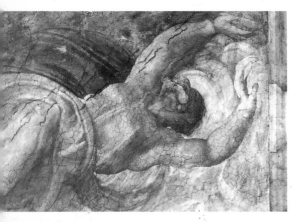

at them from below. Perhaps a small price to pay for being the man responsible for one of the most important achievements in the history of art.

An unusual view of God, seen from underneath, busy dividing the light from the darkness; pictured before the recent restoration of the ceiling.

Michelangelo didn't want to do the ceiling *at all*. He was still sulking with Pope Julius II (*see page* 106) after the massive project to sculpt a tomb in St. Peter's had been dumped, and he was convinced that the Sistine Chapel was some kind of plot devised by his enemies. Reluctantly, he took on assistants to help him. Then, suddenly, he sacked them all for incompetence, barred the door of the

chapel, and set about transferring his great vision to the ceiling all by himself—refusing to let anyone in until he'd finished.

He used more than 200 preliminary sketches, all made into cartoons (*see page* 26) and transferred on to the wet plaster day by day, while battling with enormous difficulties. Some of the early work got mouldy and had to be done again; he ran out of money; the Pope kept bothering him

1511 The Scottish warship *Great Michael* is launched.

1511 In the Vatican's Stanza della Segnatura, Raphael paints four aspects of human accomplishment: theology, philosophy, the arts, and law.

1512 Overthrow of the Florentine Republic by Lorenzo, grandson of Lorenzo the Magnificent.

The Dying Slave

Instead of breathing a sigh of relief after all his efforts on the ceiling, the Sistine Chapel seems only to have invigorated Michelangelo. He went straight back to the pope's tomb, full of plans to decorate it with a series of statues of prisoners. The tomb might have been a hopeless dream, but there was one memorable result: his extaordinary statue of *The Dying Slave* (1516), now in the Louvre.

for a completion date; but finally, there it was—a great hymn to the spiritual awakening of mankind, surrounded by gigantic figures from the Old Testament. There they all are, ever so civilized, reading, talking, and arguing with each other like university professors.

Whole books have been written about the ceiling and the gigantic leap of imagination it took to behold this universe filled with these giant but dignified naked figures. But here's a brief list of things to look for. First, the central picture of God creating Adam—an image so influential that our mental pictures of the deity have followed Michelangelo's pattern ever since. Second, the great sibyls and naked male figures called *ignudi*, with a range of poses and body types and expressions, like nothing that anybody had ever painted before. Third, the strange, and possibly even blasphemous, portrait of God foreshortened—as if seen from below—separating the light from the darkness, directly above the altar.

Suffusing it all is the idea of the artist as a solo practitioner, without a workshop of assistants to help him, flat on his back in the equivalent of a garret.

In his own words

This is how Michelangelo describes his labor in one of his sonnets:

"My beard towards heaven, I feel the back of my brain

Upon my nape I grow the breast of a harpy;

My brush, above my face continually,

Makes it a splendid floor by dripping down."

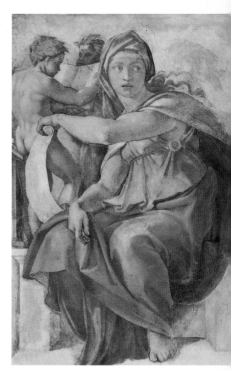

The Delphic Sibyl (1509), the first of the five pagan prophetesses that Michelangelo portrayed on the ceiling.

1512 In Flanders Josquin des Prez, now in his seventies, receives universal praise as Europe's greatest composer; his works include 19 masses, 100 motets, 70 chansons, and a handful of instrumental pieces.

1517 Spanish explorer Francisco Fernández de Córdoba observes traces of a Mayan civilization in the Yucatán.

1521 Magellan is killed in a fight with the natives on Mactan Island in the Philippines.

1508~1560
The Grand Tour
The Romanists

While all that fervent activity was going on down in Italy, the great artists of the north were on the rise too, exporting their pictures to Italy and enjoying Italian art in return. The sense that art was up to something was especially strong in places where the traditions crossed over, especially in ports full of foreign visitors such as Antwerp. So perhaps it wasn't surprising that it was the artists of Antwerp who set off on some of the first "Grand Tours," wanting to see for themselves the archaeologists at work on the Roman ruins. They took the road south, in the footsteps of Dürer, and brought all those innovative southern ideas back with them to mix them up with their own.

Still life
Jacopo de Barbari was deeply influenced by Dürer, and is credited with painting the first ever still life in the history of art. It has a particularly inspiring title: *Dead Bird* (1504).

They were known as the Romanists, obsessed with the classics, desperate to show off their mastery of perspective, and their admiration for the work of Michelangelo and Raphael. Their paintings were steeped in religion and classicism too, but they were still keen to paint some particularly northern things, which often tended to be pretty ordinary: bankers, strange old women or pleasant views. Even so, the result was often enjoyably over the top—with florid detail or deliberate horror.

Gossaert's *Neptune and Amphitrite* (1516): he first became interested in painting classical nudes after his visit to Italy, but his figures lack the famous Italian sense of "proportion."

1522 The poems "Colin Clout" and "Why Come Ye Nat to Courte?" by John Skelton are clerical satires directed against the rising power of Cardinal Wolsey.

1527 Chemotherapy is pioneered by a Basel physician.

1542 Mary Stuart is born and ascends to the throne of Scotland at a week old.

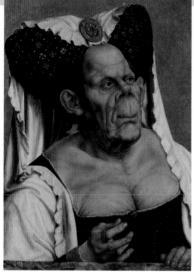

Quinten Massys' *Grotesque Old Woman* (1510/20), supposedly a portrait of the Duchess of Tyrol, would be used as a model for the Queen in *Alice in Wonderland*.

His contemporary, *Jan van SCOREL* (1495–1562), came from Amsterdam, and made the trip south to Venice in 1519 to meet Giorgione. But he didn't stop there. He went straight on to Jerusalem and drew a picture of Bethlehem. In 1522, there happened to be a Dutch pope, Adrian VI. He made Van Scorel curator of the famous Belvedere Collection of classical sculptures in Rome after the death of Raphael.

Then there was *Quinten MASSYS* (*c.* 1465–1530), also from Antwerp, who visited Italy sometime between 1514 and 1519, came home and built himself a house with frescos painted all over the outside. As well as religious subjects, he specialized in portraits, genre scenes, and satirical jibes at the middle classes.

ALL ROADS LEAD TO ROME

First off was the painter *Jan GOSSAERT*, also known as Mabuse (*c.* 1478–1532), who took the road to Italy in 1508 and dashed back with his head full of classical nudes. Together with his colleague, *Jacopo de BARBARI* (*c.* 1440–1516), he set about painting the first of these in the north (see his *Neptune and Amphitrite* of 1516), and, in traditional Renaissance style, got the men right but made a botched job of the women.

NAMES IN THE FRAME

The Romanists didn't just consist of this little quartet. Others caught up in the whole affair included **Lucas van Leyden** *(1489/94–1533), who traveled around Flanders with Gossaert;* **Maerten van Heemskerck** *(1498–1574), a friend of Scorel's who made it to Italy himself in 1532; and the great tapestry and stained-glass designer* **Bernard van Orley** *(1498–1541), court painter to the Spanish governors of the Netherlands.*

1513 There is a peasant rebellion in Switzerland.

1514 In Cuba, a Spanish missionary campaigns against the atrocities he has witnessed under the "encomienda" system.

1515 *Sofonisba*, the first blank verse play, is published.

1509~1520
Philosophical Poses
The Vatican rooms

While Michelangelo was on his back painting the Sistine ceiling, the man who would be his bitter rival had popped up in Rome, made friends with the Pope, and was busy painting the first of three rooms—or stanze—in the Vatican palace. Raphael's first room, the Stanza della Segnatura (Room of the Signature), made his reputation. After this, there could be no stopping the man until death caught up with him (in fact, not that long after). Only Michelangelo and his accusations of plagiarism stood in his way (see page 102); but Michelangelo was no match for Raphael's charm.

Promotion
By the time Raphael had reached his third room, he was a busy man indeed. In 1514, he was appointed to take over from Bramante as the chief architect of St. Peter's (*see page 80*) – and showed that his contribution to architecture was to take Bramante's simple style and add carved decoration all over it. He was also director of all the archaeological excavations around Rome until his death.

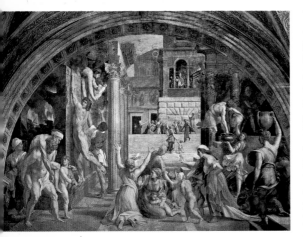

Raphael's *The Fire in the Borgo* (1514–17): a representation of real events in the Vatican in the year 847. A calm-looking Pope Leo IV may be seen in the background waving to the desperate crowd.

Raphael's fresco, *The School of Athens*, painted in the Stanza della Segnatura—planned as Julius II's library—inspired millions afterward, almost as many as Michelangelo's greatest works. In it, Raphael painted Aristotle and Plato and all the great philosophers gathered together in a massive classical structure that might have been designed by his mentor, the architect Bramante (*see page 80*). He even slipped in a picture of himself, and modeled Plato on Leonardo, who was about to arrive in Rome again.

1516 "De Rebus Oceanicus et Novo Orbe" by Italian historian and royal chronicler Pietro Martire d'Anghiera, is the first published account of the discovery of America in 1492.

1517 There are May Day riots in London, protesting against foreigners.

1520 Smallpox takes a heavy toll at Veracruz. It will eventually kill half the population of New Spain.

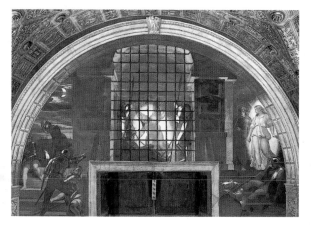

The *Liberation of St. Peter* (1514–17): note the use of real daylight in the picture behind the angel, to make it stand out.

As with much of Raphael's work, there was a quiet dignity about his figures—although *Fire in the Borgo* (1514–17) is a little tormented, showing Michelangelo-style figures desperately trying to escape from the flames.

MIRACULOUS EVENTS

The next room, the Stanza d'Eliodoro (Room of Heliodorus, *c.* 1512–13), depicted a mixture of miraculous events from the history of the Church, including the *Liberation of St. Peter*, painted around a window to make the angel appear in a shining light. But poor old exhausted Julius II died before it was finished, and his third room, Stanza dell' Incendio (Room of the Fire), had to be commissioned under Leo X. The release of St. Peter, the first pope, from his chains, was also a reference to Julius' death—in fact Julius was buried in a church called St. Peter in Chains.

This, and the Sala di Costantino, were mainly painted by Raphael's army of assistants, who were helping him keep up with the vast number of commissions he was getting, and scholars have been arguing ever since about just how much he was personally responsible for.

The School of Athens has been said to be the High Renaissance at its apotheosis, but it's the other rooms which best demonstrate Raphael's trademark sense of constant movement and energy.

NAMES IN THE FRAME

When Raphael dropped dead from the plague, the final stanza was finished by his chief assistant, **Giulio Romano** *(1492/9–1546), later one of the founders of Mannerism (see page 124). It has a more crowded, dramatic feel to it, without the balance of Raphael's work.*

1512 In England, a law is passed removing benefit of the clergy for many serious crimes.

1520 "Appeal to the Christian Princes of the German Nation" by Martin Luther, has a first printing of 4,000 copies and sells out in a week.

1521 Cortès captures Mexico City.

1510~1535
The Big Ego
Machiavelli

Machiavelli, as seen by the sculptor Antonio del Pollaiuolo.

There's nothing like losing your job if you war to find your true vocation in life—even if you don't recognize it yourself. And so it was with the great political theorist Niccolo MACHIAVELLI (1469–1527), who made his name in history with the books he wrote after being thrown out of office.

Cesare Borgia in 1513, the model for Machiavelli's book *The Prince*, with his pragmatic lack of scruples.

He worked in the service of the new Florentine republic from when it was first proclaimed until the Medicis clawed it back again in 1512 and he ended up in prison. For the rest of his life he tried to find his way back into public service, but tried so hard that, when he finally seemed near to achieving his goal, he was rejected as being too close to the Medicis after all.

It's strange that somebody who so mismanaged his own political destiny should have his name enter the language as a byword for successful political machination—but then, that's one of the ironies of politics.

All-round talent
Machiavelli was also a successful poet and playwright. His comic plays *Mandragola* (1518) and *Clizia* (1524-5) were among the most popular of their day. Another Renaissance Man.

1523 The Mennonite religion is founded in Zurich when a small community leaves the state church to pursue a form of Christianity that emphasizes the sanctity of human life.

1525 Chili peppers and cayenne from the Americas are introduced by the Portuguese into India, where they will become the ingredients of the hottest curries.

1533 Titian becomes court painter to Charles V.

NEW KINDS OF PRINCE

Throughout his life Machiavelli was obsessed with working out ways for a state to resist attack from outside. So he came up with the "humanist" notion that rulers are not bound by the same morals as you and me. The result of this thinking, *The Prince* (1513), marked another step towards the Renaissance idea of mankind. It disposed of the old idea that rulers owed their allegiance to God, and paved the way towards the coming rise of statehood.

He should have known. In the course of his diplomatic career, he met the French king, the German emperor, the Pope, and saw a great deal of the Borgias as they expanded their land in the heart of Italy, studying their tactics close-up. He also wrote the *History of Florence* (1525) in the new Renaissance style—an interpretation of cause and effect, rather than a medieval-style list of dates and divine interventions.

NAMES IN THE FRAME

Where did Machiavelli get his more theoretical ideas? The answer may be from the long-dead Greek historian of the foundation of Rome, **Polybius** *(d. 120 BC). His enthusiasm for the ancient Roman constitution and his detailed knowledge about military campaigns, the laying out of armed camps, and all the other detailed military know-how in his famous book* The Art of War *(1521) was all probably gleaned from Polybius.*

Simone Martini's picture of medieval leadership (1340s); but times were changing as minor princelings ceded to the rise of nationalism.

1516 In Britain, craftsmen are banned from selling their wares.

1520 At Wittenberg, Martin Luther publicly burns the papal bull resulting in his excommunication.

1527 Margaret of Navarre establishes an intellectual court at Agen, Château de Nerac, giving shelter to clerics who question their church.

1510~1576

A Splash of Color
Titian

Even if you only live to 37 or younger, like Raphael, it's still possible to change the course of art—but to really stamp yourself upon a century you have to live for one. Tradition has it that TITIAN (Tiziano Vecelli)—despite accepted life dates of c. 1485–1576— lived for 99 years. He probably didn't, but he certainly carried on painting well into extreme old age (see The Crowning with Thorns, *c. 1570).*

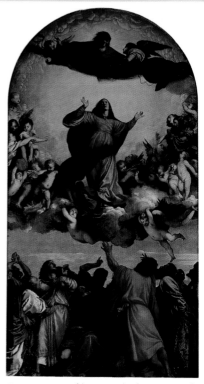

Titian's *Assumption of the Virgin* (1518): note the triangle of red figures. The monks who commissioned the painting were unsure whether to accept it or not.

Not surprisingly for such longevity, Titian went through phases—you would do after a good 70 years in front of the canvas. He progressed from the style he had learned under Bellini and in Giorgione's workshop in Venice, through the quiet sensual period in the middle of his career, before embarking on the explosive and mythological paintings he did at the end of his life— he called them

Sansovino
Titian and his two friends— the shocking writer and satirist Pietro Aretino (1492–1556) and the sculptor Jacopo Sansovino (1486–1570)—formed a kind of "triumvirate" that made all the decisions on art in Venice. Sansovino's work still dominates the city in the shape of Library of San Marco (1537), supposed to look like an ancient Roman amphitheater from the outside.

"poesie"—for the leader of the Counter-Reformation, Philip II of Spain.

Titian astonished Venice in 1518 when his gigantic *Assumption* was unveiled in the Frari Church in Venice. There was Mary, dressed in bright vermilion, rising up to heaven—none of those ordinary madonnas that Raphael was still painting

1530 Painted enamel on copper appears for the first time at Limoges, France.

1573 Queen Elizabeth I's jewelry collection (enlarged almost daily with gifts) is thought to be the most valuable in Europe; any items considered inferior in either quality or value are sold to offset household costs.

1574 In Istanbul Sultan Selim the Drunkard dies of a fever after cracking his head open in a Turkish bath while in a drunken stupor.

—with the apostles below in a state of some agitation. The famous Venetian calm and grace had disappeared forever and a new chapter in the history of art had been written.

Titian went to Rome in 1543, painted Pope Paul III (1545–6) and his unpleasant nephews, and met Michelangelo. He was already the chief painter of Venice, dominating the artistic life of the city for generations, and a close friend of the emperor Charles V. Although Michelangelo praised his "lively" paintings, he criticized his drawing—but the "divine" Michelangelo was already out of date. Titian was pushing forward the boundaries of technique by working over and over his paintings with oil, sometimes shocking his contemporaries by giving up brushes altogether and using his fingers instead.

Have a look at his *Diana and Acteon* in the National Gallery, and his *Sacred and Profane Love* (1515), one of the first female

> ### NAMES IN THE FRAME
> *Titian just went on and on, as younger artists fell by the wayside—like* **Lorenzo Lotto** *(c. 1480–1556) and his Venetian landscapes. Or in Parma,* **Antonio Correggio** *(1489/94–1534) whose* Assumption *on the local cathedral dome was described by one of the canons as "a hash of frogs' legs." Or* **Palma Vecchio** *(c. 1480–1528), who had a thing for Venetian blondes. Or* **Giovanni Antonio Pordenone** *(1483/4–1539), who liked swirling figures.*

studies of the High Renaissance in Venice. While you're about it, take in *Perseus and Andromeda* (c. 1560), painted for Philip II. Like the *Assumption* more than 40 years before, he has the figures twisting in the strange new way.

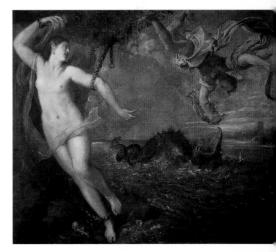

Titian's *Perseus and Andromeda* (c. 1560): he specialized in figures seen the wrong way up, suspended awkwardly in midair.

1516 Mary Tudor is born, later known as "Bloody Mary" because of the mass executions of Protestants during her reign.

1523 In Germany a group of Franconian knights become bandits, terrorizing the Nuremberg countryside.

1524 Francisco Pizarro proposes an expedition to "Piru": he tells Panama's governor about a land to the south where people drink from golden vessels and have animals (llamas) that are half sheep, half camel.

1515~1543

In Your Face
Holbein and the spread of portraiture

When the English king Henry VIII ran short of wives, he got into the habit of sending the portraitist Hans Holbein abroad to paint the candidates. Tradition has it that Holbein fell for Anne of Cleves so much that his portrait made her seem more beautiful than she actually was.

The result: Henry only clapped eyes on her at the wedding and his fourth of six marriages ended swiftly in divorce.

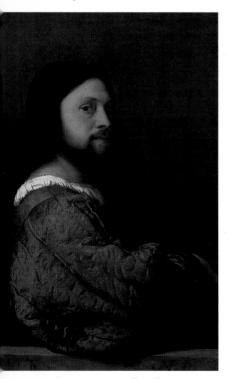

Titian's dramatic *Portrait of a Man* (1511) may very well be a picture of himself, staring confidently out at the canvas at us.

If it's true, the story says something about *Hans Holbein the Younger* (1497/8–1543)—the greatest northern portrait painter of the age. He achieved all the precision of northern Renaissance painting in his careful recording of details of costume, and yet he was able to put a spark of individuality into the pictures he painted. This lifelike element is one of the battlegrounds between Italian art historians and the rest. Italians tend to say it's just a kind of photography—not real art at all. Northerners call it the "effect of the real": it isn't real but it convinces us in any case. Either way, Holbein painted more than just what he saw. Check out, for example, *Bonifacius Amerbach* (1519) and his famous pictures of Sir Thomas More and family (*see page 101*).

Individuality was a Renaissance idea, and it built on a renewed tradition of classical faces, starting with "portrait

1527 The Muslim Somali chief Ahmed Gran invades Ethiopia with firearms, taking a deadly toll. The Negus appeals for Portuguese aid.

1536 Henry VIII's second wife Anne Boleyn is beheaded after being accused of adultery.

1542 The Irish summon a parliament in June and six Gaelic chiefs approve the act that makes Henry VIII King of Ireland.

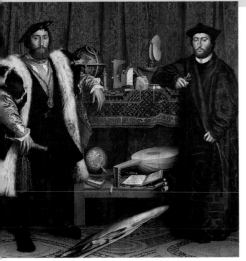

Holbein's *The Ambassadors* (1533): a portrait of power. Seen from the side, the dagger in the foreground is actually a skull.

"three-quarter view." A good example is Titian's *Portrait of a Man* (1511). Such portraits reveal a series of proud new versions of Renaissance humanity, like Piero della Francesca's portrait of Federigo da Montefeltro, the Duke of Urbino (c. 1472). But none is prouder than Holbein's *The Ambassadors* (1533), with the French ambassador and the Bishop of Lavour staring imperiously out of the double portrait. But suddenly, at this high point of human pride, the memento mori pops back again, as the swordlike object at the feet of the ambassadors is revealed to be a distorted skull.

medals" of local dignitaries by artists like Desiderio da Settignano and Antonio Pisanello (c. 1395–c. 1455). Renaissance tombs soon followed suit: the decorations on graves were forgetting for a moment the traditional medieval memento mori— skulls, hellfire, and the like—and adopting realistic portrayals of the dead person as they were when they were alive.

But it was Leonardo and Bellini who started the trend for realistic three-dimensional faces seen slightly from the side—known as

NAMES IN THE FRAME

Holbein's German colleague **Lucas Cranach** *(1472–1553) was also important as a portrait painter, probably inventing the idea of the full-length portrait when he came to paint* Henry the Pious of Saxony and his Duchess *(1514). But sadly, his 1550 portrait of Titian has long since disappeared. Other portraitists included the father and son team,* **Jean Clouet** *(d. 1540/1) and* **François** *(d. 1572), who were court painters of France.*

RENAISSANCE ART ~ A CRASH COURSE **121**

1513 Chartres Cathedral is completed 60 miles southwest of Paris after nearly 400 years of construction.

1522 Huldreich Zwingli condemns celibacy and Lenten fasting, and calls on the Bishop of Constance to permit priests to marry.

1524 Giovanni da Verrazano explores the North American coast, discovers a "beautiful" harbor and gives the name Angoulême to the island that will later be called Manhattan.

1517~1560

Here I Stand
Luther and the Reformation

Something had to give. Thanks to the humanists, the clergy were no longer the only source of learning and scholarship. The sale of indulgences was being stepped up to pay for the new St. Peter's. The growth of literacy and books meant that people were able to read the Bible for themselves, if they were allowed to. The stage was set for the period of religious disruption and reform known as the Reformation.

An influential tome: Luther's Bible (1522) in German hit a popular vein.

It was the indulgences that particularly upset the reformers, and they were the subject of the *Ninety-five Theses* of 1517, published by an irritable German monk named *Martin LUTHER* (1483–1546), and nailed to the door of the Castle Church in Wittenberg. Luther was excommunicated for his efforts, summoned to appear before the emperor Charles V at the Diet of Worms in 1521, and urged to take them back. "Here I stand," he is supposed to have said. "I cannot do otherwise." It was a revolutionary statement of individuality that would have been unrecognizable before the new kind of art developed in Italy. He stayed in hiding for almost a year, translating the New Testament into German and pouring out his angry pamphlets. A generation before nobody would have listened, but Luther had chosen a critical moment in history.

NAMES IN THE FRAME

The enormous expense of St. Peter's and the indulgences sold to pay for it also inspired other early Protestants, such as the Swiss **Huldreich Zwingli** *(1484–1531), the Scots* **John Knox** *(c. 1513–72), the French* **John Calvin** *(1509–64), and Luther's more compromising German ally,* **Philip Melanchthon** *(1497–1560).*

1539 French army surgeon Ambroise Paré develops ingenious mechanical devices for those who've lost limbs on the battlefield.

1543 The Portuguese become the first Europeans to reach Japan.

1560 Eric XIV succeeds to the Swedish throne and unsuccessfully courts England's Queen Elizabeth I.

Posthumous burning

Luther's followers were also moving slowly in the footsteps of the pioneering English Protestant John Wycliffe (1330–84) and his Bohemian colleague Jan Hus (1372–1415), both of whom were burned at the stake (Wycliffe luckily after he had already died – of natural causes).

Luther was the first, but his doctrines also chimed harmoniously with the spirit of the times. The mood was shifting toward the reformers, whose big idea was a direct relationship between individuals and God. You couldn't buy your way to salvation—it must come through the grace of God. In fact, you could bypass the Church altogether by reading the Bible yourself, the source of all inspiration. What's more, the new generation of powerful princes such as England's Henry VIII all wanted excuses to flex their muscles against the interference of the Pope. With its sense of the dignity of man, the Renaissance world could no longer quite accept the old Catholic emphasis on sin and rigid authority, and—although humanism certainly wasn't Protestantism —it did provide the kind of environment where Protestants could suddenly pop up.

Luther's ideas plunged Germany into religious and civil conflict in the Peasants' War, which was followed by hostilities between Catholic and Protestant princes across Europe until 1555. The Peace of Augsburg then allowed each German princeling to choose between Catholicism and Lutheranism, and then enforce their choice on their own subjects.

It wasn't exactly religious freedom, but that was how it was seen at the time. It also meant a new kind of individualism and nationalism that marked out the next five centuries, and is one of the lasting results of the Renaissance.

Lucas Cranach's woodcut of the Papacy (1520s): it wasn't very flattering. Cranach was a friend of Luther and painted several portraits of him as well as designing propaganda woodcuts.

1523 Diego Columbus, son of Christopher, is stripped of all offices inherited from his father.

1558 French country doctor Michel de Nostradamus publishes his prophetical *Centuries*.

1561 The latest addition to Queen Elizabeth I's elaborate wardrobe is a gift of silk stockings from one of her servants.

1520~1580

Strange and Unusual
Mannerism

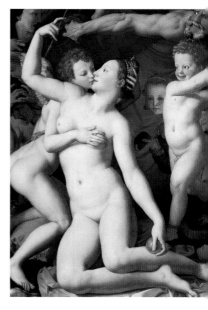

Bronzino's *Venus, Cupid, Time and Folly* (1540–5), with its strange-shaped bodies: it has been described as "icy obscenity."

Once you've got an educated audience for art, the temptation is to play with the rules a little. You know you'll intrigue the people who understand what you're doing and you'll shock everyone else. It's what radical young artists do every generation or so—and as the Renaissance was drawing to a close, that's exactly what some of them did. The result was a late Renaissance movement that became known as Mannerism.

Mannerist paintings, sculpture, and architecture all pushed the rules of the Renaissance to an extreme. The rules of perspective are accepted but then broken, the nudes are elongated or have muscles in all the wrong places. The paintings are full of bizarre colors and images. The poses are strained. Yet somehow they also build on the twisted muscular nudes of Michelangelo and the theatrical poses of Raphael. Even Michelangelo, who just went on and on, may have produced a Mannerist painting in *The Last Judgment* (1536–41).

Why did it happen? The Marxist explanation is, predictably, the Sack of Rome, so traumatic that artists abandoned all that calm serenity of the previous generation. The

Northern manners

Mannerism hit the north about the same time, but in a different form, and including a group of anonymous painters active between 1510 and 1530 who specialized in the same affected poses and florid style, and were known as the "Antwerp Mannerists." Others included Adriaen Isenbrandt (d. 1551) from Bruges, and the portrait painter Lucas Cranach the Elder (*see page 121*), whose *Cupid Complaining to Venus* (1530) includes a fashionable nude in a very fashionable hat.

1562 William Cecil builds the first conservatory in England to protect his subtropical plants.

1576 Pineapple, chili pepper, vanilla, peanuts, bananas, olives, lettuce, and citrus fruits are very fashionable foods in Europe.

1579 Puritan gentleman John Stubbe has his right hand cut off for circulating a pamphlet objecting to a mooted marriage between Elizabeth I and Francis, brother of French King Henry III.

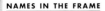

NAMES IN THE FRAME

Many of the other Mannerists were pretty peculiar. The architect **Giulio Romano** *(1492/9–1546) was sane enough, and so was the sculptor* **Giovanni Bologna** *(1529–1608). But* **Jacopo Pontormo** *(1494–1556), who trained Bronzino, left behind a neurotic diary showing that he was obsessed with his bowels. And* **Giovanni Battista Rosso** *(1494–1540), who took the style to France (see page 126), may well have committed suicide.*

practical explanation is that Raphael was just so damn good the only way forward was to change the genre. The psychological explanation would have it that many of the key artists involved were deeply neurotic. The traditionalists thought it was decadent and a break with Renaissance ideals. But the classical poses are still there, and so is the fascination for psychological depth. We're still in the Renaissance, but more so. Then there's the simple Vasari explanation (*see page* 136). If Michelangelo was the greatest artist in history, then the only way to go was downward. No wonder the Mannerists were so obsessed with the idea of decline.

Take a look at *Venus, Cupid, Time and Folly* (1540–5), by the great Mannerist *Agnolo* BRONZINO (1503–72), which shows

long, elongated bodies getting incestuous with each other. Another good example is the *Madonna and Child with St. Zacharias*, by *Francesco* PARMIGIANINO (1503–40). He was later imprisoned for breach of contract for painting a series of frescos in Parma extremely slowly; after his release, he gave up art entirely for alchemy.

Cranach the Elder's *Cupid Complaining to Venus* (c. 1530) is elongated and jokey, and illustrates the Mannerist ideals of the late Renaissance.

1536 England begins to suffer shortages of honey after monasteries, which raised honeybees as a source of wax for votive candles, are dissolved.

1540 A specimen potato from South America reaches Pope Paul III via Spain.

1543 The Spanish Inquisition burns Protestants at the stake for the first time.

1530~1600
Scroll Over
Fontainebleau

King Francis I: how could he attract the greatest painters to come and work in France?

Whether or not KING FRANCIS I of France (1494–1547) really held the dying Leonardo da Vinci in his arms, one thing's for sure: he certainly got bitten by the Italian Renaissance bug. The trouble was, he found it difficult to get any other Italian artists to bless him with their presence in Paris. Fra Bartolommeo (see page 97) turned him down. Jacopo Sansovino (see page 75) set off, but only got as far as Venice, where he stayed put. The Florentine artist Andrea del SARTO (1486–1530) came but dashed back to his wife after just a year. It was uphill work.

But finally, in the 1530s, the first trickle of Italian artists started to arrive, beginning with *Giovanni ROSSO (see page 125)* from Florence, and *Francesco*

PRIMATICCIO (1504/5–70) from Mantua. They were nearly all Mannerists, and because many of them helped decorate Francis' hunting lodge at Fontainebleau, they became known as the First School of Fontainebleau. They established the French Mannerist school and changed French art forever.

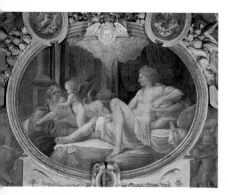

Sumptuous decoration and even a little bit of scrollwork by Primaticcio in 1530s at the royal hunting lodge at Fontainebleau, Paris.

TECHNO BOX
The year 1530 also marked the suggestion by the great French humanist scholar and royal librarian Guillaume Budé (1467-1540) that a college at Fontainebleau should be set up. The King agreed, and the Collège de France was established. Its library became the basis for the Bibliothèque Nationale. Budé was an expert in the classics, writing about Roman law, ancient coinage, and Greek literature.

1554 *La Vida de Lazarillo de Tormes y sus Fortunes y Adversidades,* the first picaresque novel, is published anonymously in Spain and condemned as immoral.

1595 Sir Walter Raleigh explores 300 miles of the Orinoco with four ships and 100 men in search of El Dorado.

1600 English scientist William Gilbert describes magnetism.

ARRIVAL OF A RIVAL

Primaticcio popped back to Rome in the early 1540s to publicize France and all that it had to offer to other young artists. When he got back, Rosso was dead, and a disturbing rival had installed himself. It was the great lover (and the man who claimed to have killed the Imperial commander during the Sack of Rome) *Benvenuto Cellini* (1500–71). Cellini welcomed Primaticcio back by threatening to kill him "like a dog."

But despite this setback, the School of Fontainebleau struck off in new directions that were entirely its own. You can recognize it by its extravagant decoration, and the first appearance of enormous curling stucco scrolls—known as "strapwork"—

decorating each room. And also by its long elegant bodies (see Primaticcio's *Chambre de la Duchesse d'Etampes* in Fontainebleau). Cellini made himself famous with his enormous gold salt cellar (1540–43).

Fontainebleau also gave birth to a new kind of architecture, rather like some of those Florentine palaces from the previous century, which you can still see in the façade of the Louvre (c. 1546f) and in pictures of the long-demolished Somerset House in London.

> **NAMES IN THE FRAME**
>
> *By 1556, Cellini was in prison for immorality, Francis I was dead, and his successor Henri IV was developing a Second School of Fontainebleau. This was a softer, more French version of the First School, led by lesser-known French artists such as* **Ambroise Dubois** *(1542/3–1614) and* **Toussaint Dubreuil** *(1561–1602).*

Cellini's monstrous saltcellar (1540–43)—10" tall by 13" wide—graced by Neptune, Tellus, and a little bit of salt.

1537 "Nova Scientia" by Italian mathematician Niccolo Tartaglia discusses the motion of heavenly bodies.

1538 Thomas Cromwell instructs the clergy that they have to keep parish records of weddings, baptisms and funerals.

1540 Michael Servetus discovers the circulation of blood through the lungs.

1537~1600

Wobbly Lines
Mercator and maps

The trouble with discovering America was that just setting off in a westerly direction wasn't really enough. The modern world needed maps, and not the medieval kind that had Jerusalem at the center and weird sea creatures round the outside. It was a problem that could have been designed for a Renaissance solution: by mixing up a knowledge of the classics with a twist of the idea of perspective.

Ptolemy's map of the universe (1543): an unnecessarily complicated business.

I nspiration came from two places. One was a century before, around the year 1400, when a long-forgotten copy of Ptolemy's book *Geographia* turned up in Florence from Constantinople. News of the discovery spread around the merchants and seafarers of medieval Italy, who were even then inching their voyages of discovery down the African coast and dreaming of a way to the Indies by crossing the Atlantic. Ptolemy had had the idea, more

Dürer explains the technique of drawing perspective by using a grid.

TECHNO BOX
Measuring mattered to the Renaissance mind. It took a Renaissance leap of imagination to draw a line down the water, as the Pope, the Spanish, and the Portuguese did—carving up the New World between them in 1493 and 1494. The line was set "three hundred and seventy leagues west of the Cape Verde Islands, being calculated by degrees."

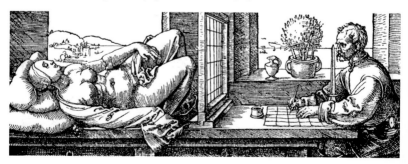

1550 In Germany Rheticus publishes trigonometrical tables simplifying calculations involving triangles.

1571 Pope Pius V orders an index of prohibited books to be drawn up.

1600 Will Kemp morris dances all the way from London to Norwich.

than a thousand years before, of putting a grid on the world to find your way across it.

A similar idea popped into Dürer's head a century later, as he described how you could use a perspective grid to copy a face. By changing the shape of the grid, he found you could change the shape of the face, but not its features.

Far away in Flanders that same year (1537), the mathematician *Gerardus* MERCATOR (1512–94) was putting the finishing touches to his revolutionary map of the world, which gave the name

Columbus' *Santa Maria*: he found his way to the New World without the aid of a map.

"America" for the first time to all the land masses on the other side of the Atlantic from what became known as the Old World.

It took another 30 years for these ideas to become codified as the "Mercator projection," which was to become the basis of all modern maps. But in 1568, he revealed his system of parallel lines of latitude and longitude, which—like Dürer's face—distorts the atlas of the world in the northern and southern hemispheres, but allows navigators to plot a straight course on a flat surface.

No more changes of compass bearing—Mercator's map, *New and Improved Description of the Lands of the World*, distorted the rules of perspective, just as the Mannerists were doing in art. We have been stuck with an image of Greenland which is unnaturally gigantic ever since.

NAMES IN THE FRAME

Renaissance scientists were charting the stars as well. While the artists were developing their ideas on perspective, the German astronomer and mathematician **Johannes Regiomontanus** *(1436–76) had been in Italy publishing books about maths. His book* Ephemerides *(1490) even listed the positions of the stars and heavenly bodies as far ahead as 1506. This saved Columbus' skin because he took a copy with him on his fourth voyage to the New World, and won over the native population of Jamaica by correctly predicting the eclipse in February 1504.*

1540 United companies of barbers and surgeons are incorporated in London.

1545 Henry VIII's new flagship HMS *Mary Rose* sinks just outside Portsmouth Harbour in less than a minute after a strong gust of wind makes her guns break loose.

1546 "The Proverbs of John Heywood" by English epigrammatist John Heywood, includes the proverb "No man ought to look a given horse in the mouth."

1540~1594

The World Upside-down
Tintoretto

The great Renaissance painters believed tradition was very important, and Jacopo Robusti, best known as TINTORETTO *(1518–94), was no exception. On the wall of his workshop, he wrote in big letters his prescription for good pictures: "The drawing of Michel Angelo and the coloring of Titian." When he felt in need of direction, he probably used it as a checklist. But in fact he had something neither of the others had: speed—he was famous for how quickly he could finish a painting.*

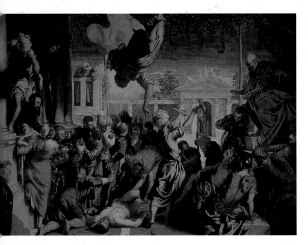

St. Mark Rescuing a Slave (1548), complete with Tintoretto gymnastics. It made his name.

going his own way, mainly around the churches of Venice, painting big mythological pictures such as *The Origins of the Milky Way* (*c.* 1578). He wasn't very interested in the classics and the great historian of the Renaissance, Vasari (*see page* 136) didn't like him at all—claiming that he treated art as a joke. It was a well-known and oft-voiced criticism of the Mannerists (*see page* 124).

Tintoretto started off having a rambunctious time as Titian's pupil before turning his hand to decorating furniture. There's very little record of his life as an artist until he was getting on for 25 years old. He finally made his reputation with *St. Mark Rescuing a Slave* (1548); by then the not-so-young man was

So how can you tell a Tintoretto from a Michelangelo or Titian? Look for three things. However much he might borrow his colors from Titian, the kind of flickering light he used was all his own. Second,

1553 Lady Jane Grey rules England for 9 days until the accession of Mary Tudor.

1571 In Spain Nicolas Monardes publishes a book praising the medicinal value of tobacco.

1590 The microscope is invented by Dutchman Zacharia Janssen.

there's the really frenetic body movements of most of the figures. His *Ascension* (*c.* 1575–81) makes you feel tired just looking at it. And third, he used dramatic foreshortening of the figures to such an extent that many of them seem to be almost upside-down.

There's an explanation for this. He would use wax models of figures in boxes, with strange lights playing on them to explore persective—something that neither Michelangelo nor Titian ever thought of, although other artists had done. So when he's drawing a figure from underneath, you

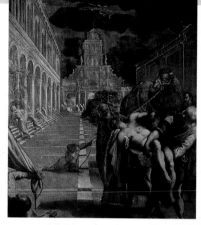

Tintoretto's *Theft of the Body of St. Mark* (*c.* 1562): his peculiar, distorted sense of space, full of tangled bodies, underlines the emotion.

can be pretty sure he's been testing out the angle with the wax versions first.

The Ducal Palace in Venice suffered a major fire in 1577, which destroyed all the decorations by Bellini and Titian. So Tintoretto's last years were spent replacing them with the largest paintings he ever produced—including his massive painting of *Paradise* (1588). Tintoretto specialized in gigantic pictures, like the 40-foot *Crucifixion* in the Scuola di San Rocco (1565).

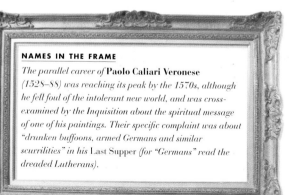

NAMES IN THE FRAME

The parallel career of **Paolo Caliari Veronese** *(1528–88) was reaching its peak by the 1570s, although he fell foul of the intolerant new world, and was cross-examined by the Inquisition about the spiritual message of one of his paintings. Their specific complaint was about "drunken buffoons, armed Germans and similar scurrilities" in his* Last Supper *(for "Germans" read the dreaded Lutherans).*

1549 The wife of Cosimo de' Medici pays 9,000 florins to buy the Pitti Palace from Buonaccorso Pitti and completes it as the Grand Ducal Palace.

1556 800,000 people are killed in an earthquake in China.

1573 England emerges alongside Italy in the front rank of modern European music: noted musicians at this time include Robert White, Thomas Tallis, and William Byrd.

1543~1600
In the Stars
Copernicus

Copernicus realizes he'll create a stir.

The pioneering Renaissance astronomer Nicolaus COPERNICUS (1473–1543) was so appalled by the consequences of his theory—that the earth revolved around the sun rather than the other way around—that he dared not publish it until he was actually paralysed and dying. He touched the printed version just a few hours before he died in his native Frauenberg. He needn't have worried: it was another 90 years before Galileo was imprisoned for saying the same thing.

Copernicus was either a Prussian or a Pole, depending on political geography, and taught briefly in Rome and Padua. Another Renaissance Man, he was also a successful currency reformer, administrator, military governor, judge, and doctor. He wrote up his astronomical theory in his book, *De Revolutionibus Orbium Coelestium (On the Revolutions of the Celestial Spheres)*, as early as 1530, arguing that the earth rotates once a day on its axis, and once a year around the sun—along with all the other planets. He did more than argue it: he calculated it using pages of figures. It was just that he dared not publish it.

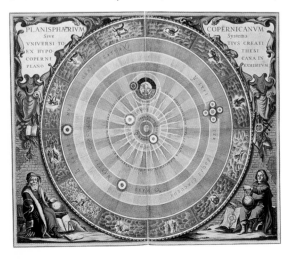

The Copernican Universe (c.1530), with the Sun firmly placed in the middle: the New Age was beginning to look like a frightening place.

1576 Dante's *La Vita Nuova* is published posthumously.

1582 Ten days vanish as the Gregorian calendar replaces the Julian calendar and October 5 is declared to be October 15.

1598 *Arcadia* is published by Spanish novelist-poet Lope de Vega, who sailed with the Armada against England in 1588.

NAMES IN THE FRAME

Only an estimated ten scientists agreed with Copernicus for the rest of the century. One was the great Italian mathematician **Galileo Galilei** *(1564–1642), preparing to present his great telescope to the Doge of Venice. Another was the German astronomer* **Johannes Kepler** *(1571–1630), whose work on orbits paved the way for Sir Isaac Newton a century later.*

An unknown artist shows Galileo being sentenced to life imprisonment in 1633.

THE CHURCH'S REACTION

In the event, the Catholic Church welcomed the work—partly because Copernicus' friends had delegated the public relations to the Protestant reformer *Andreas OSIANDER* (1498–1552), who had added his own cringing preface which claimed that it was all just a working hypothesis. It was actually the Protestants who reacted with fury: Luther called Copernicus an arrogant fool. Melanchthon said the doctrine should be instantly suppressed.

Copernicus looks like a Renaissance scientist, bringing the old medieval doctrines tumbling down, but it's more complicated than that. The Renaissance had shifted God from the center of the universe and put humanity there instead; Copernicus began the next shift, replacing us with the sun. Shifting the central place of man in cosmology flew in the face of Michelangelo's grandeur and Luther's individualist zeal—and paved the way for the uncertainties of the next generation. No wonder Luther didn't like it.

Bruno

One of the people Copernicus influenced most was the wandering philosopher and poet Giordano Bruno (1548–1600), who escaped from the Dominican order when they tried to punish him for his beliefs. Teaching throughout Europe, he was increasingly criticized for his argument that the universe was infinite: "There is a single general space," he wrote, "a single vast immensity which we may freely call Void." He was denounced to the Inquisition and burned at the stake in Rome.

1550 The work of fiction *Facetious Nights* by Italian writer Giovanni Francesco Straparola is the first European collection of fairy tales.

1550 The Japanese *daimyo* (feudal lord) who welcomed Francis Xavier to Kyushu in August 1549 makes it a capital offence to become a Christian after midsummer.

c1555 In Europe metal nuts and bolts appear for the first time.

1549~1580

Pillars and Posts
Palladio

By the middle of the century, the great artists of the Renaissance were getting tired. Michelangelo and Titian were still creaking away, fighting their old battles, but the world was moving on. Then all of a sudden, there was a new Renaissance revolution in architecture that kept going for more than three centuries. And all because of an impressionable young man from Vicenza named Andrea di Pietro dalla Gondola, later known as PALLADIO (1508–80).

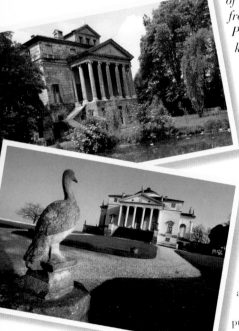

Palladio's Villa Foscari (1555–60) with a colonnaded portico raised above basement level.

The Villa Rotunda (1567) has a central domed hallway with four equal living units around it, in perfect symmetry.

In his youth, he had two big influences. The first was the poet *Gian Giorgio TRISSINO* (1478–1550), who supervised the young man's architectural studies, took him to Rome and got him to change his name. The second was the work of the ancient Roman architect Vitruvius. Palladio studied what he saw until he emerged with the key guidebook to Roman ruins for the next 200 years, *Antiquities of Rome* (1554). He also emerged as one of the most important European architects since ancient times.

In 1546 he got his first big commission: putting a façade on the medieval town hall of Vicenza, known as the Basilica. And for the next three decades, he churned out villas in a whole new style, such as the Villa

1570 Moscow's Czar Ivan the Terrible attends the public executions of almost all his close advisers and ministers.

1573 Suffolk farmer Thomas Tusser publishes "Five hundred good points of Husbandry"—a book of rhymed proverbs designed to help fellow farmers.

1580 An earth tremor kills two people in London and damages St. Paul's Cathedral.

Inigo Jones

The Palladian style went to sleep for a century or so as Europe tore itself apart, but—thanks to the efforts of the English architect Inigo Jones (1573–1652), who came to Italy to collect together Palladio's papers—the style had its own major Renaissance in 18th-century England. It was followed shortly afterward by 19th-century America. Palladian grandeur has never really gone away.

Palladio was in great demand among the Vicenzan aristocracy and we still live in buildings inspired by him.

Foscari, Villa Capri, and Villa Rotunda. They had big pediments of the kind you used to find outside Roman temples, held up by rows of columns, often with stairs balancing each other on either side. Here were all the Renaissance ideas of harmony and grandeur rolled into one—and subtly

flattering to anyone who happened to own it. He even changed the arrangement of rooms, with a range of different-sized rooms around a central hall, and wings stretching out on either side.

It was centuries since the ancient Romans had relaxed in their villas. Most couldn't afford a place in the countryside as well as the town and, if they did, it needed to be fortified. All those rich Italian noblemen, reorganizing the agricultural economy during this period of prosperity, swallowed the new designs whole.

Palladian architecture has appealed to the rich and powerful ever since, wherever they need entrances of imposing grandeur to front their houses.

NAMES IN THE FRAME

*The 16th century was an exciting period in Italian architecture, which was still reeling from the impact of Bramante. There was **Jacopo Sansovino** (see page 75), whose death made way for Palladio's new career designing churches in Venice. There was also the Veronese military engineer **Michele Sanmicheli** (1484–1559) or Giulio Romano (see page 125) working in Mantua.*

1550 Prices in Europe rise as coins minted from Mexican and Peruvian gold and silver ingots devalue the old currencies.

1559 The University of Geneva has its beginnings in an academy founded by John Calvin and the French Protestant reformer Théodore de Bèze.

1560 Venice gets its first coffee house.

1550~1574

Guru Status

Vasari and the invention of genius

The great chronicler and critic at work.

Renaissance history was all about great individuals who shape events. And while Machiavelli was putting the idea into practice by looking at the great politicians, Vasari was preparing to do exactly the same for artists. His book, Lives of the Most Excellent Painters, Sculptors, and Architects, *was not just a long hymn of praise to the individual geniuses of the Renaissance, but it was probably also the most influential book of art criticism ever written.*

Renaissance spin doctor: Vasari's portrait of himself at the age of 55, while he was reworking his *Lives*: he thought that modern art had reached perfection.

Giorgio VASARI (1511–74) was a workaholic. He was also an artist himself—definitely a Mannerist (*see page* 124)—and was so precocious that, despite being the son of a potter, he was taken up by the Medicis and sent to school along with their children in Florence. The Grand Duke *Cosimo I MEDICI* (1519–74) remained his patron until their deaths, getting Vasari in to design houses, paint ceilings, and anything else that came along.

He produced a vast amount of work, with distinctive Mannerist decoration. He designed the great Renaissance art gallery, the Uffizi in Florence, but he has been remembered best for his writing. The job

he set himself in 1543, when he sat down to it, was not just to write about the great men of the Renaissance and to give them life in a way that Boccaccio managed with his characters (*see page* 20)—but also to record their methods and interests. Painting and sculpture had come a long

1561 *Gorboduc*, by English playwrights Thomas Norton and Thomas Sackville, first Earl of Dorset and grandmaster of England's Freemasons, is the earliest known English tragedy.

1570 *Cooking Secrets of Pope Pius V* by Bartolomeo Scappi is published in Venice with 28 pages of copperplate illustrations.

1572 In Cuzco, Tupac Amaru, the last of the Incan rulers, is beheaded by the Spanish despite an attempt by leading clergymen to grant him a reprieve.

way over the past two centuries: it was now the stuff of learned discussion—and Vasari was extremely well placed to write it all down. After all, he knew many of the characters involved.

With this information, he submitted the great works of the period to a series of gruelling tests. Were they harmonious? Was the design graceful? Did it achieve what the artist had set out to do? It was a whole new language of discussion, and centuries of art critics have followed where Vasari led. The by-product of all this is that centuries of art historians have rejected the artistic achievements of the so-called Middle Ages because they were so focused on the Renaissance years.

Biography

Michelangelo wasn't altogether pleased with what Vasari wrote about him in his 1550 *Lives*, and encouraged an "authorized biography" by one of his pupils, Ascanio Condivi, to set the record straight. But as the years went by, Vasari got to know him better and produced a second (1568) edition, which is a pretty good guide to the way Michelangelo saw things, too.

NAMES IN THE FRAME

Vasari was responsible for many of the ways we still see the Renaissance. He divided the birth of art into three periods: the first phase (he called it Childhood), inspired by Giotto; the second phase (Youth) by Masaccio; and the third phase (Maturity) by the great figures of the High Renaissance—Leonardo, Michelangelo, and Raphael—when artists had, as he put it, gone "beyond the hand of nature." However, watch out for his pro-Tuscan bias!

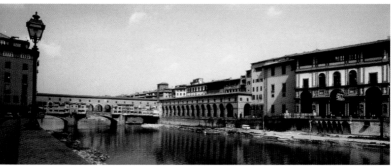

Vasari's Uffizi Palace in Florence (1560–74), seen from across the Arno: originally government offices, it now houses the famous Uffizi Gallery.

1588 In China, due famine some peasants reduced to grinding sto for flour, having alreac stripped the countrysid anything that grows.

1603 Queen Elizabeth I, now sick and elderly, calls for a mirror and sees her own (frightening) reflection for the first time in twenty years.

1624 The privy council bans further performances of Thomas Middleton's *A Game At Chesse* which deals with the failure of Prince Charles to secure a wife in Spain.

1550~2000

The Renaissance Renaissance
How we've used the word since then

"What a piece of work is a man!" said Hamlet, in Shakespeare's classic Renaissance soliloquy. "How noble in reason! How infinite in faculty! In form, in moving, how express and admirable! In action, how like an angel! In apprehension how like a god!" If anyone had asked him, and I'm sure they did, Michelangelo probably wouldn't have put it any differently.

The American Declaration of Independence had many authors.

The point is that, although the Renaissance had evolved into something else in Italy and had given way to the intolerances of the Counter-Reformation and the power of Baroque, its influence was still spreading throughout Europe. The architecture of the great European universities was inspired by the great Renaissance libraries and places of learning—you can imagine Michelangelo's godlike creations striding around the gigantic quadrangle in Christ Church, Oxford. Shakespeare was the great Renaissance playwright: it wasn't a coincidence that so many of his plays were set in Italy. Every country had its very own Renaissance: the word almost came to mean "golden age."

Meanwhile, scientists were developing a new approach to the natural world based on humanity's dominance over nature, leading to the insights of Sir Isaac Newton and the

Much Ado About Nothing: Shakespeare was the great Renaissance playwright.

1685 Two Scotswomen, Margaret McLauchlan and Margaret Wilson, are sentenced to death in Dumfries for refusing to deny their Catholic beliefs.

1750 Johann Sebastian Bach completes "The Art of the Fugue" but dies on July 28, at age 65.

1964 GI Joe, a doll for boys, is introduced by Hasbro, a US toy maker.

The French Revolution of 1789 was based on Renaissance ideas of the fundamental dignity of mankind.

dawn of modern science. The new numerical system and interest in trade were inspiring a fresh approach to life that put humans at the center, and led to the new pseudo-science of economics and the insights of the Scottish economist and philosopher Adam Smith.

And as the centuries wore on, still the young aristocrats of Europe spent a formative couple of years on the so-called Grand Tour, wandering through the towns of Italy glimpsing the great achievements of culture. Then they brought it home, like Inigo Jones to London, to start a new Renaissance in architectural styles and Palladian architecture, which soon spread west from Britain to the American colonies.

In politics, too, you can see the influence of those democratic classical ideals, popping up again in the American Declaration of Independence in 1776 or Tom Paine's *Rights of Man*, or in the crowd storming the Bastille shouting "Liberté, Egalité, Fraternité!"

And in periods when politics has settled down a little, the most important legacy of the Renaissance remains: the idea that art is vitally important, and more importantly, that artists are important, too, and that every society needs them.

And now?

Are we having a Renaissance now? In some ways the collectivism of the 20th century, and the reaction against humanity's mastery over the universe, have meant turning away from the Renaissance ideals. And yet there are rebirths all around us—the New Age movement has been described as a Renaissance of spiritual understanding, and the flowering of popular culture since the Beatles has been described as a Renaissance of art. Every year Renaissances are hailed and expire. And probably every last one of them reacts against or reestablishes some of the great thoughts of late medieval Italy.

Looking upward into the dome of St. Paul's Cathedral, London, designed by Wren: a Renaissance building if ever there was one.

Glossary

Before engaging in knowing conversation on Renaissance art, we recommend you study this glossary of art terms—that way you'll never confuse your "frottola" with your "sfumato."

ALTARPIECE
A religious painting, usually on the front of an altar.

ANNUNCIATION
The moment when the Angel Gabriel appears to Mary to tell her she is going to give birth to a son, which is the moment that God becomes Man (see Incarnation).

BAPTISTERY
The part of a church used for baptisms.

BRONZE
Metal used for sculptures, made from a mixture of copper and tin.

BUON FRESCO
The technique of painting on wet plaster (see Fresco). This is more frequently used than fresco secco.

CARTOON
A sketch of a planned painting, drawn on heavy paper. It comes from the Italian word cartone, which means "cardboard."

CASTING
Creating sculptures and statues by pouring molten metal into a mold.

CHIAROSCURO
Gradations of color from highlights to dark shadows in the composition of a painting. The technique was pioneered by artists such as Raphael.

EGG TEMPERA
An emulsion consisting of water, paint pigment, and egg yolk. It is quick-drying and hardens into a tough sheen.

ENGRAVINGS
Prints taken from a picture cut into metal, stone, or wood.

FORESHORTENING
Using perspective techniques when reproducing a body or other object so that it appears shorter (see Perspective).

FRESCO
Painting onto wall plaster. The word means "fresh" in Italian.

FRESCO SECCO
An experimental technique of painting directly onto dried plaster on a wall. Secco means dry.

FROTTOLA
A secular Italian song, and a forerunner of madrigals.

INCARNATION
The union of God and Man in Jesus Christ.

INTONACO
The rough plaster put on the wall underneath the fresh stuff before a fresco is painted.

MADONNA
The Virgin Mary, usually portrayed with child.

MANNERISM
The extreme, jokey style of art adopted toward the end of the Renaissance (see page 124).

MEMENTO MORI
A skull or similar image used to remind us that death comes to everyone.

NATIVITY
The birth of Christ.

NATURALISM
An artistic style in which things are shown as they really are. More or less.

OIL PAINT
Created from mixing paint pigments with slow-drying oils, like linseed. Oils revolutionized painting, allowing a greater range of colors and effects.

PASSION
The suffering of Christ at the Crucifixion.

PERSPECTIVE
The technique that gives a three-dimensional effect to drawings and paintings by making scenes smaller as they get further away, until they disappear into the distance.

PIETÀ
A representation of Mary, the mother of Christ, with the body of her son.

RELIEF
A sculptured picture in which the scene stands out from a flat surface.

SFUMATO
The slightly blurred shadowy effect pioneered by Leonardo da Vinci and made possible by oil paints. The word means 'smoky'.

TRIPTYCH
Altarpiece composed of three painted panels. The two outer panels fold over to cover the central panel.

UNDERPAINTING
In traditional oil painting the early stage of the composition during which the monochrome is laid in.

VANISHING POINT
The spot on the horizon where lines of perspective seem to meet and disappear.

Index

Alberti, Leon Battista 33, 44, 50–1, 60
Altdorfer, Albrecht 57
Angelico, Fra 48–9
Aretino, Pietro 90, 118

Bacon, Roger 33
Barbari, Jacopo de 93, 113
Bartolommeo, Fra 97, 126
Bellini, Gentile 65
Bellini, Giovanni 64–5, 75, 121
Bellini, Jacopo 64
Berenson, Bernard 69
Boccaccio, Giovanni 10, 20–1, 23, 67, 136
Bologna, Giovanni 125
Borgias 83, 88–9, 106, 116, 117
Bosch, Hieronymus 72–3
Botticelli, Sandro 49, 59, 68–9
Bouts, Dieric 57
Bracciolini, Poggio 31
Bramante, Donato 51, 63, 80–1, 102, 114
Bronzino, Agnolo 124, 125
Bruegel, Pieter 56
Brunelleschi, Filippo 18, 19, 32–3, 34, 35, 36, 51
Bruni, Leonardo 30, 31
Bruno, Giordano 90, 91, 133
Bude, Guillaume 126

Calvin, John 122
Campin, Robert 44, 45, 47
Caravaggio 31
Carpaccio, Vittore 75

Castagno, Andrea del 20, 49
Catena, Vincenzo 109
Caxton, William 67
Cellini, Benvenuto 127
Clouet, Franáois 121
Clouet, Jean 121
Colet, John 101
Colonna, Vittoria 53
Columbus, Christopher 41, 86–7, 92, 129
Condivi, Ascanio 85, 137
Copernicus, Nicolaus 132–3
Correggio, Antonio 119
Cortés, Hernan 87
Cosimo, Piero di 57
Cranach, Lucas 121, 123, 124, 125

Dante Alighieri 10, 18, 20–1
D'Aragona, Tullia 53
Darat, Jacques 47
Dias, Bartolomeu 87
Donatello 11, 18, 30, 32, 35, 36–7, 51, 58, 105
Dubois, Ambroise 127
Dubreuil, Toussaint 127
Duccio di Buoninsegna 17
Dürer, Albrecht 60, 64, 94–5, 128, 129

Erasmus, Desiderius 100–1, 107
Este family 89
Eyck, Jan van 27, 45, 46–7, 54, 56–7

Fabriano, Gentile da 13, 62
Fontainebleau School 126–7
Franco, Veronica 53
Froben, Johann 101

Galileo 83, 132, 133
Gama, Vasco da 87
Geertgen tot Sint Jans 73
Ghiberti, Lorenzo 18, 33, 34–5, 36, 51
Ghirlandaio, Domenico 19, 85
Giorgione 65, 108–9, 113
Giotto 15, 21, 22–3, 26–7, 43
Gossaert, Jan 112, 113
Gutenberg, Johann 66–7

Heemskerck, Maerten van 113
Holbein, Hans 120–1

Jones, Inigo 135, 139
Julius II, Pope 29, 63, 81, 84, 85, 89, 97, 103, 106–7, 110, 115

Kepler, Johannes 133
Knox, John 122

Leonardo da Vinci 31, 44, 55, 57, 76–7, 121
death 29, 126
 Last Supper 27, 81
 Mona Lisa 9, 98–9
 and Pacioli 93
 science 82–3
 sodomy 52
Leyden, Lucas van 113
Linacre, Thomas 101
Lippi, Filippino 48, 68, 69
Lippi, Fra Filippo 48–9, 68
Lombardo family 70–1
Lorenzetti, Ambrogio 16, 17
Lorenzetti, Pietro 17
Lotto, Lorenzo 119
Luther, Martin 67, 122–3, 133

Machiavelli, Niccolo 30, 63, 67, 89, 90, 91, 116–17
Mantegna, Andrea 31, 39, 64, 80

Manutius, Aldus 101
Manzetti, Giovanni 38
Martini, Simone 17, 117
Masaccio 18, 32, 40, 41, 42–3, 49, 62, 73
Masolino di Panicale 35, 42–3, 62
Massys, Jan 25
Massys, Quinten 113
Medicis 19, 58–9, 63, 80, 85, 104, 106, 116, 136
Melanchthon, Philip 41, 122, 133
Mercator, Gerardus 129
Messina, Antonello da 55, 74
Michelangelo 18, 22, 29, 35, 38, 52, 84–5, 96, 130–1
David 8, 104–5
and Julius II 106–7
Leonardo rivalry 76
Mannerism 124
Medicis 59
and Raphael 102, 114
Sistine Chapel 110–11
and Titian 119
tomb sculpture 71
and Vasari 137
Michelet, Jules 13
Michelino, Domenico da 21
Michelozzo di Bartolommeo 19, 37, 50, 51, 58
Monteverdi, Claudio 91
More, Sir Thomas 101, 120

Neithardt–Gothardt, Mathis 95
Nelli, Abbess Plautilla 53
Nicholas of Cusa 40–1
Nicholas V, Pope 62

Orley, Bernard van 113
Osiander, Andreas 133

Pacioli, Luca 92–3
Palestrina, Giovanni Pierluigi da 79
Palladio 63, 75, 90, 134–5
Parmigianino, Francesco 125
Patenier, Joachim 57, 108
Perugino, Pietro 14, 61, 103
Petrarch 10, 14, 17, 20–1, 30, 57
Petrucci, Ottaviano 79
Piero della Francesca 44, 60–1, 121
Piombo, Sebastiano del 109
Pisanello, Antonio 121
Pisano, Giovanni 16, 43
Poliziano, Angelo Ambrogini de 59
Pollaiuolo, Antonio del Jacopo Benci 71, 105
Polybius 117
Pontormo, Jacopo 125
Pordenone, Giovanni Antonio 119
Primaticcio, Francesco 126–7
Ptolemy 128–9
Pythagoras 61

Quarton, Enguerrand 45

Raphael 22, 63, 81, 96, 102–3, 114–15, 124–5
Regiomontanus, Johannes 129
Romano, Giulio 115, 125
Rossellino, Antonio 37
Rosso, Giovanni 125, 126, 127
Ruffo, Vincenzo 79

Sangallo, Giuliano 63
Sanmicheli, Michele 135
Sansovino, Jacopo 75, 118, 126, 135
Sarto, Andrea del 126
Savonarola, Girolamo 52, 59
Scorel, Jan van 113
Serlio, Sebastiano 91

Settignano, Desiderio da 37, 121
Sforza, Lodovico 83, 92
Shakespeare, William 91, 138
Signorelli, Luca 61, 105
Stradano, Giovanni 24

Tintoretto 75, 130–1
Titian 29, 64, 65, 75, 96, 97, 109, 118–19, 120, 121, 130–1
Torrigiano, Pietro 97
Trissino, Gian Giorgio 134

Uccello, Paolo 32, 33, 35, 41
van der Goes, Hugo 47

Vasari, Giorgio 77, 85, 96, 104, 125, 130, 1367
Vecchio, Palma 119
Veneziano, Domenico 49, 61
Veronese, Paolo Caliari 75, 131
Verrocchio, Andrea del 27, 30, 31, 37, 68, 76
Vespucci, Amerigo 87

Waldseemuller, Martin 87
Weyden, Roger van der 28, 45, 47
Witz, Konrad 57
Wyclif, John 123

Zwingli, Huldreich 122

B

Hachette Books

Hachette Book Group

1290 Avenue of the Americas

New York, NY 10104

HachetteBookGroup.com

Printed in the United States of America

Phoenix Color

Book design by Alex Miles Younger

First Hachette Books edition: April 2015

10 9 8 7 6 5 4 3 2 1

Hachette Books is a division of Hachette Book Group, Inc.
The Hachette Books name and logo are trademarks of Hachette Book Group, Inc.

The Hachette Speakers Bureau provides a wide range of authors for speaking events. To find out more, go to www.hachettespeakersbureau.com or call (866) 376-6591.

The publisher is not responsible for websites (or their content) that are not owned by the publisher.

ISBN: 978-0-316-38662-3

B

By Sarah Kay

Illustrated by Sophia Janowitz

hachette
BOOKS

NEW YORK BOSTON

If I should have a daughter,

instead of Mom, she's going to call me Point B.

Because that way she knows that no matter what happens, at least she can always find her way to me.

And I'm going to paint the solar systems
on the backs of her hands,
so she has to learn the entire universe before she can say,

"Oh, I know that like the back of my hand."

And she's going to learn that this life will hit you
hard,
in the face;

wait for you to get back up,
just so it can kick you in the stomach,

but getting the wind knocked out of you is the only way
to remind your lungs how much they like the taste of air.

There is hurt here
that cannot be fixed
by Band-Aids or poetry.

So the first time she realizes that Wonder Woman
isn't coming, I'll make sure she knows
she doesn't have to wear the cape all by herself.

Because no matter how wide you stretch your fingers,
your hands will always be too small
to catch all the pain you want to heal.

Believe me, I've tried.

And Baby, I'll tell her, don't keep your nose
up in the air like that. I know that trick;
I've done it a million times.

You're just smelling for smoke
so you can follow the trail
back to a burning house,
so you can find the boy
who lost everything in the fire
to see if you can save him.

Or else—

find the boy
who lit the fire
in the first place,
to see if you
can change him.

But I know she will anyway.

So instead,
I'll always keep an extra supply of
chocolate and rain boots nearby,

 because there is no heartbreak that chocolate can't fix.

Okay, there's a few heartbreaks that chocolate can't fix. But *that's* what the rain boots are for.

Because rain will wash away everything, if you let it.

I want her to look at the world through
the underside of a glass-bottom boat,

to look through a microscope at the galaxies that exist
on the pinpoint of a human mind,

because that's the way my mom taught me—

That there'll be days like this.

There'll be days like this, my mama said.

When you open your hands to catch,
and wind up with only blisters and bruises;

when you step out of the phone booth and
try to fly, and the very people you want to
save are the ones standing on your cape;

when your boots will fill with rain,
and you'll be up to your knees in
disappointment.

And *those* are the very days you have
all the more reason to say thank you.

Because there's nothing more beautiful than the way
the ocean refuses to stop kissing the shoreline,
no matter how many times it's swept away.

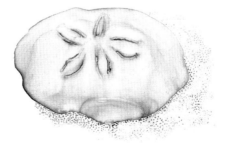

You will put the wind in win(d)some,

 lose some.

You will put the star in starting over and over.

And no matter how many land mines erupt
in a minute, be sure your mind lands on
the beauty of this funny place called life.

And yes,

on a scale from one to over-trusting,

I am pretty damn naive.

But I want her to know that this world is made out of sugar: it can crumble so easily, but don't be afraid to stick your tongue out and taste it.

Baby,

I'll tell her,

remember your mama is a worrier,
and your papa is a warrior, and you
are the girl with small hands and big eyes
who never stops asking for more.

Remember that good things come in three's.

And so do bad things.

And always apologize when
you've done something wrong.
But don't you ever apologize
for the way your eyes refuse
to stop shining; your voice is small,
but don't ever stop singing.

And when they finally hand you heartache,
when they slip war and hatred under your door,
and offer you handouts on street-corners of
cynicism and defeat, you tell them that they

really ought to meet your mother.

This poem was originally written for live performance. A video of Sarah performing this poem at the TED 2011 Conference in Long Beach, CA can be seen at: www.kaysarahsera.com

Acknowledgments

This book exists thanks to the magic and hard work of Sophia Janowitz, the patience and wisdom of Seth Godin and Alex Miles Younger, and the confidence and faith of Kelly Stoetzel, Chris Anderson, and the Scarecrow Brigade.

This poem exists thanks to the support and guidance of the NYC Urbana Poetry Slam, the Bowery Poetry Club, all the poets that light up the New York City poetry community, and mentors like Taylor Mali, Cristin O'Keefe Aptowicz, Jeanann Verlee, Anthony Veneziale, the Ferril-McCaffreys, and Rives.

These drawings exist thanks to the sight and insight of Joel Janowitz, Sarah Wainwright, Jan Kawamura-Kay, Jeffrey Kay, Deanne Urmy, Doug Fitch, Anne Lilly, Lily Herman, Michael Leibenluft, Katrina Landeta, Marianna Pease, and Rebecca, Marina, Mandy, and Terry Hopkins.

This joy exists thanks to the patience and love of family (you know who you are), friends who might as well be family (you know who you are), and especially Sophia Janowitz, James Schonzeit, Tatiana Gellein, Phil Kaye, Emily Borromeo, Kayla Ringelheim, Alex Kryger, and the Higher Keys.

This girl exists thanks to Mom, Pop, and PK.
And Lion and Blankie.

About the Author and Illustrator:

Sarah Kay collects stories. Born and raised in New York City, Sarah began performing her poetry when she was fourteen years old. She made herself a home at the Bowery Poetry Club, where she was adopted by an unruly family of poets. In 2004, Sarah founded Project V.O.I.C.E. (Vocal Outreach Into Creative Expression) to encourage creative self-expression through Spoken Word Poetry. She has since performed and taught in venues and classrooms all over the world including the United Nations, where she was the featured poet for the launch of the *2004 World Youth Report*. In 2006, Sarah joined the NYC Urbana Poetry Slam team for the National Poetry Slam in Austin, Texas and was the youngest poet in the competition. That year, she was also featured on the sixth season of the television series *Russell Simmons presents HBO Def Poetry Jam*. In 2011, Sarah was a featured speaker at the TED Conference in Long Beach, California, where she performed her poem, "B." In between being a vagabond poet, Sarah can be found writing postcards, making documentary videos, and craving smoothies.

Sophia Janowitz spends most of her time making things. Over the past year, she has worked on a range of projects in theater, film, TV, stop-motion animation, and education. Most recently, she created props and sets with the production company Giants Are Small for *The Cunning Little Vixen* with the New York Philharmonic at Lincoln Center, and she helped build immersive sets for Punchdrunk's Off-Broadway production of *Sleep No More*. In 2010, Sophia collaborated on the shooting, editing, and writing of the feature-length film, *The Student Body*. Her illustrations have been featured in Yale University's *Manifesta* magazine and *The Yale Daily News*. Twice a day, Sophia can be found drawing people on the New York City subway.

Sarah and Sophia have been friends since they were three months old. Once, at age four, they were put in timeout for finger-painting all over the white wall of Sophia's bedroom. It was worth it.